COLORING DC
WONDER WOMAN™

WONDER WOMAN
created by William Moulton Marston.

SUPERMAN
created by Jerry Siegel and Joe Shuster.
By special arrangement with the
Jerry Siegel family.

SUPERGIRL
based on characters created
by Jerry Siegel and Joe Shuster.
By special arrangement
with the Jerry Siegel family.

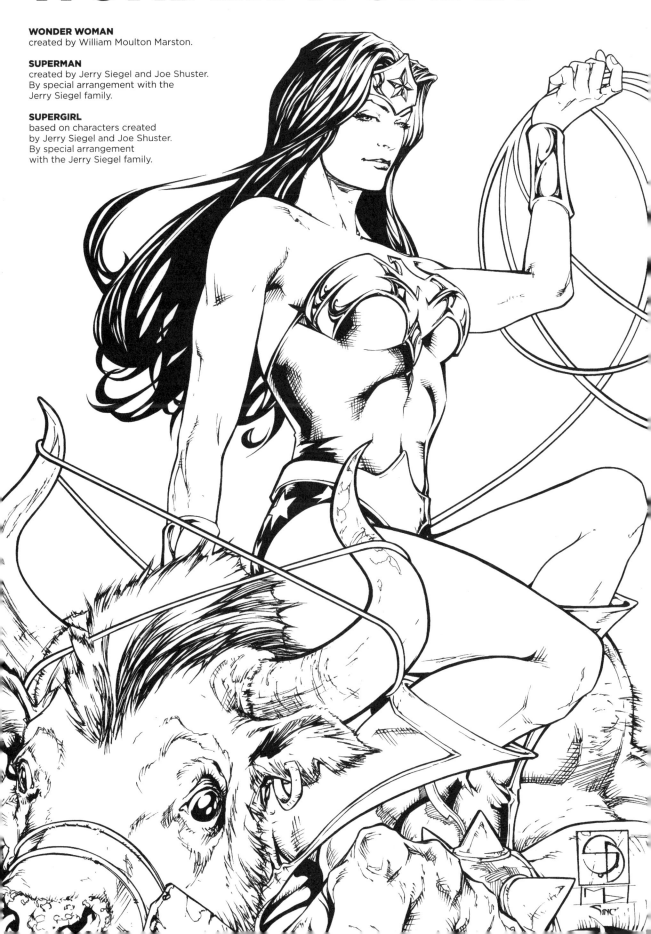

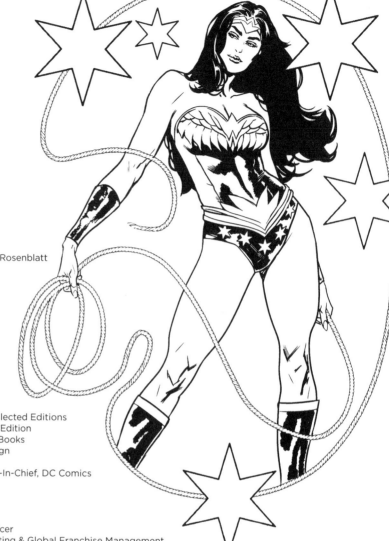

Editors
– Original Series

Brian Augustyn
Eddie Berganza
Karen Berger
Jim Chadwick
Mark Chiarello
Ernie Colon
Chris Conroy
Mike Cotton
Brian Cunningham
Will Dennis
Alan Gold
Matt Idelson
Robert Kanigher
Paul Kupperberg
Sheldon Mayer
Jack Miller
Denny O'Neil
Joe Orlando
Kristy Quinn
Marv Wolfman

Associate Editors
– Original Series

Nachie Castro
Jessica Chen
Lysa Hawkins
Paul Kaminski
Rex Ogle
Rickey Purdin
Sean Ryan

Assistant Editors
– Original Series

Jeremy Bent
Valerie D'Orazio
Ruben Diaz
Jason Hernandez-Rosenblatt
Andrew Marino
Anthony Marques
Tom Palmer, Jr.
David Piña
Julius Schwartz
Casey Seijas
Darren Shan
Ted Udall
L.A. Williams

Jeb Woodard — Group Editor – Collected Editions
Liz Erickson — Editor – Collected Edition
Steve Cook — Design Director – Books & Publication Design

Bob Harras — Senior VP – Editor-In-Chief, DC Comics

Diane Nelson — President
Dan Didio and Jim Lee — Co-Publishers
Geoff Johns — Chief Creative Officer
Amit Desai — Senior VP – Marketing & Global Franchise Management
Nairi Gardiner — Senior VP – Finance
Sam Ades — VP – Digital Marketing
Bobbie Chase — VP – Talent Development
Mark Chiarello — Senior VP – Art, Design & Collected Editions
John Cunningham — VP – Content Strategy
Anne Depies — VP – Strategy Planning & Reporting
Don Falletti — VP – Manufacturing Operations
Lawrence Ganem — VP – Editorial Administration & Talent Relations
Alison Gill — Senior VP – Manufacturing & Operations
Hank Kanalz — Senior VP – Editorial Strategy & Administration
Jay Kogan — VP – Legal Affairs
Derek Maddalena — Senior VP – Sales & Business Development
Jack Mahan — VP – Business Affairs
Dan Miron — VP – Sales Planning & Trade Development
Nick Napolitano — VP – Manufacturing Administration
Carol Roeder — VP – Marketing
Eddie Scannell — VP – Mass Account & Digital Sales
Courtney Simmons — Senior VP – Publicity & Communications
Jim (Ski) Sokolowski — VP – Comic Book Specialty & Newsstand Sales
Sandy Yi — Senior VP – Global Franchise Management

COLORING DC: WONDER WOMAN

PEFC Certified

Printed on paper from
sustainably managed
forests and controlled
sources

PEFC/29-31-75 www.pefc.org

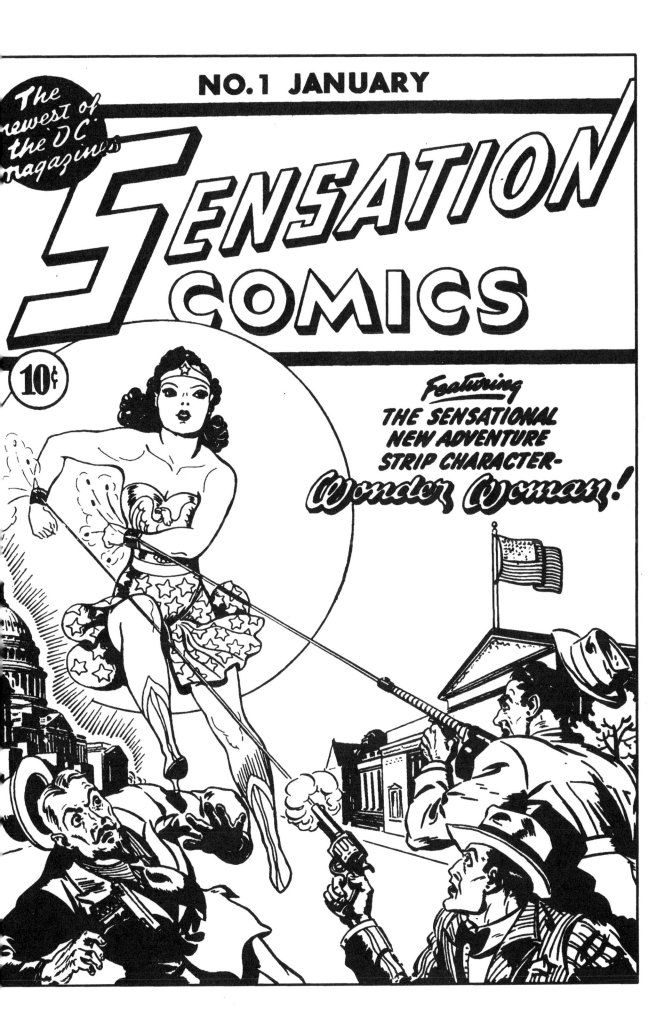

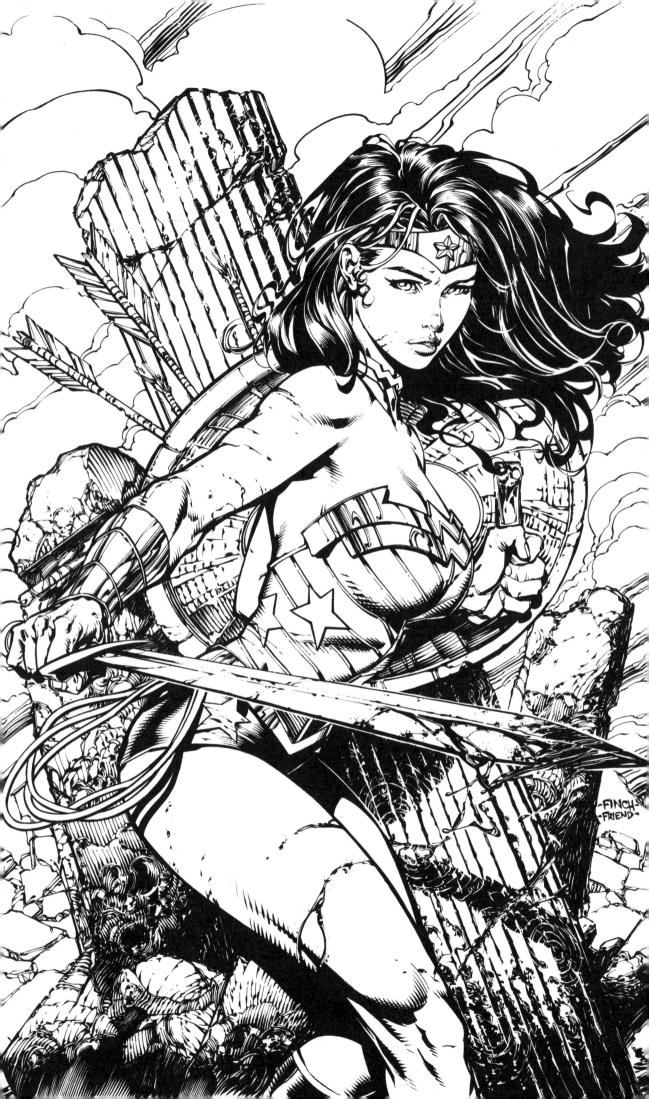

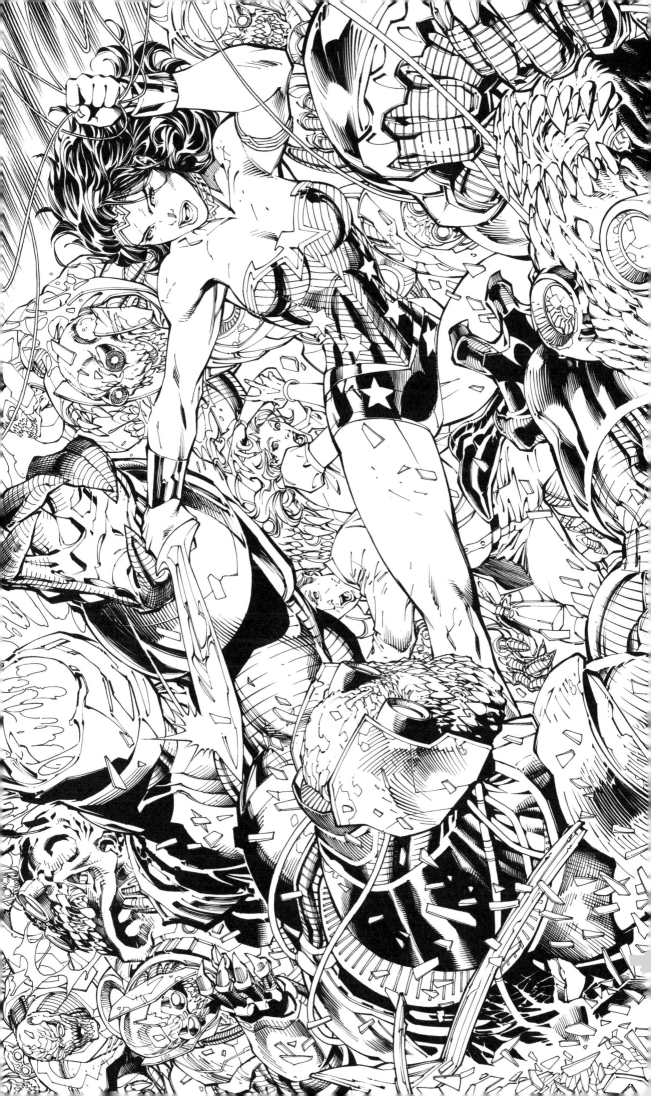

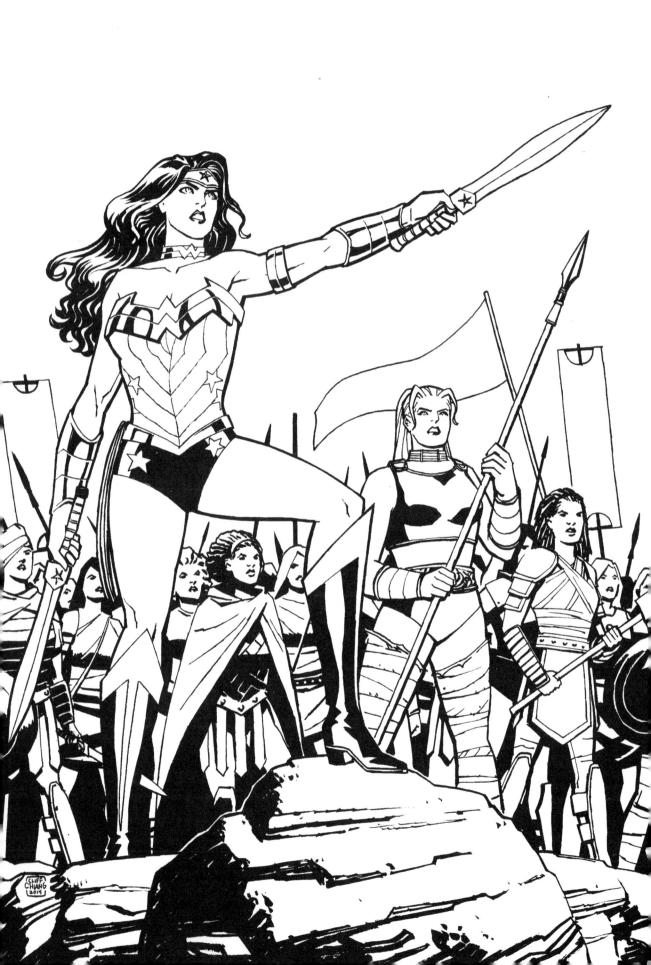

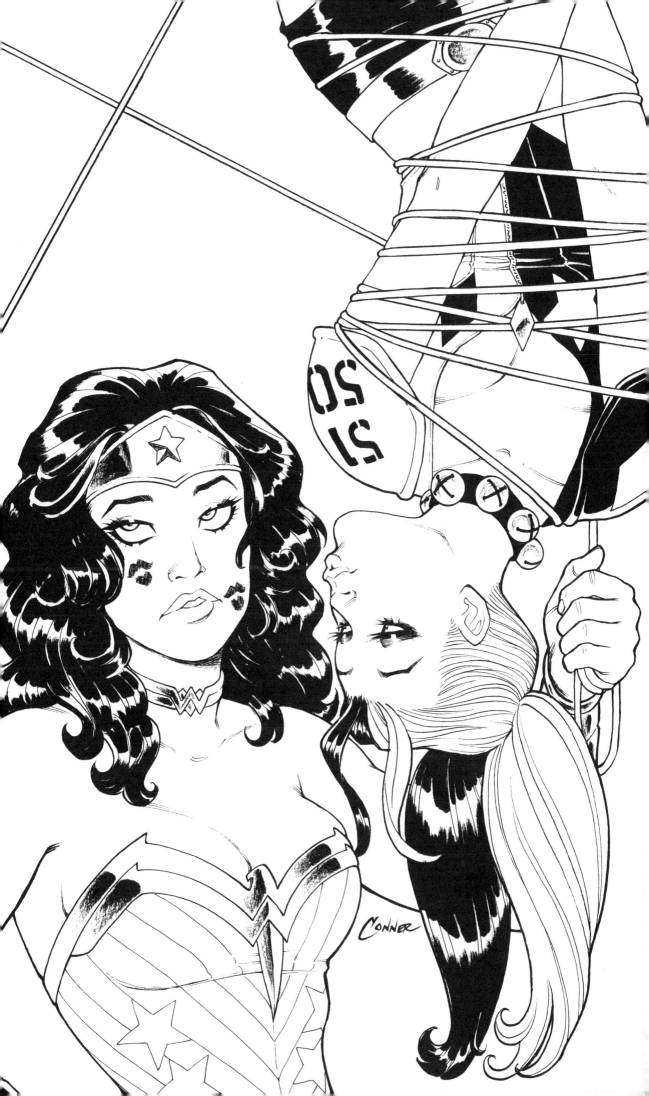

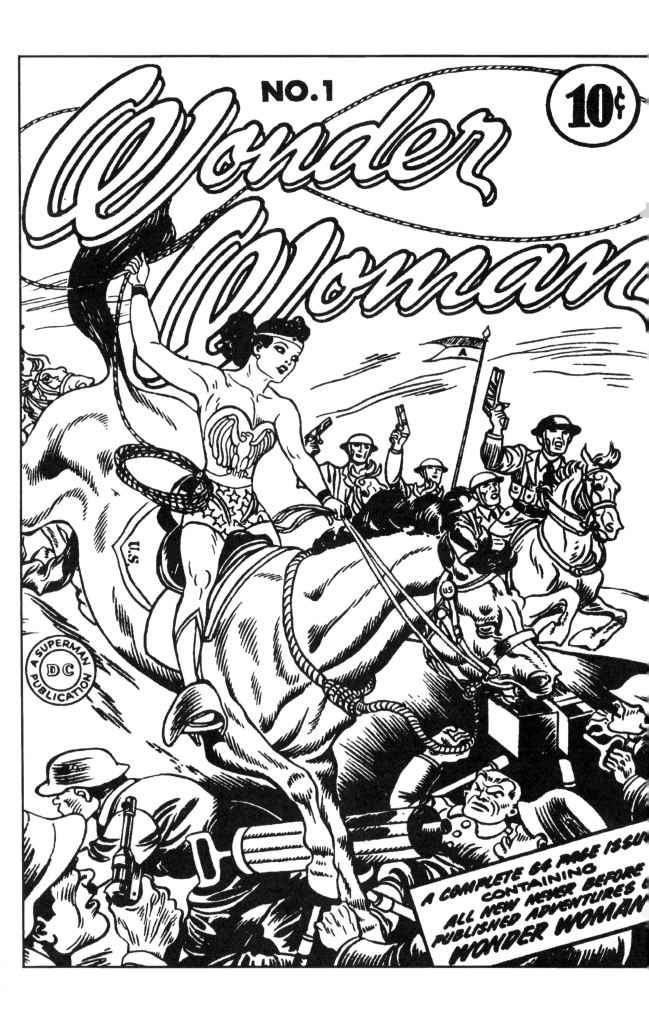

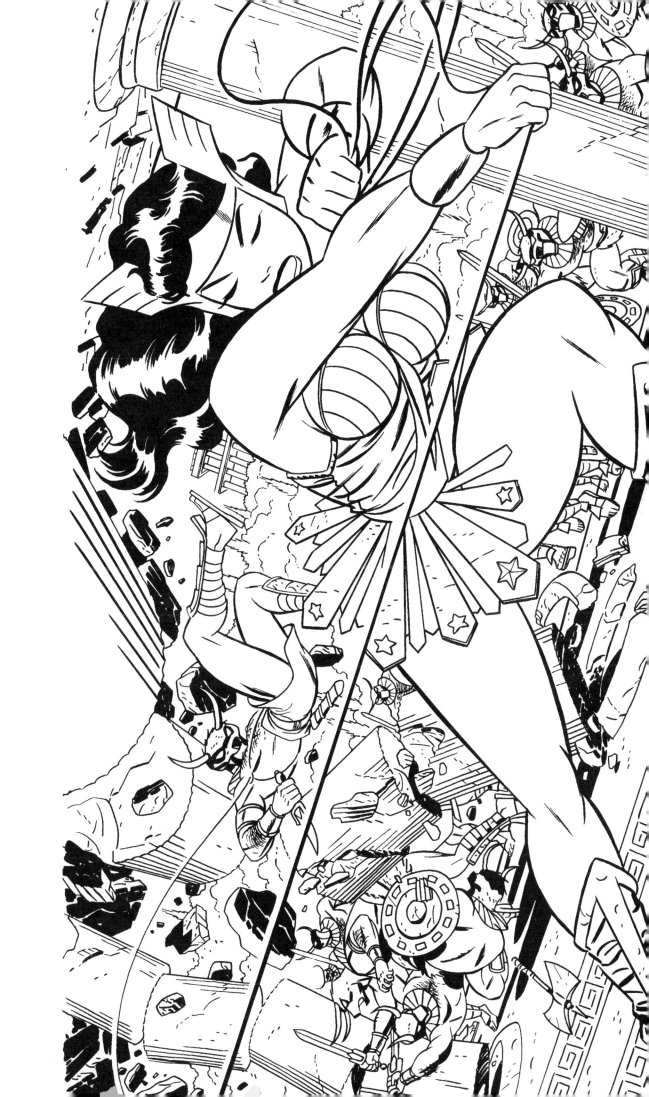

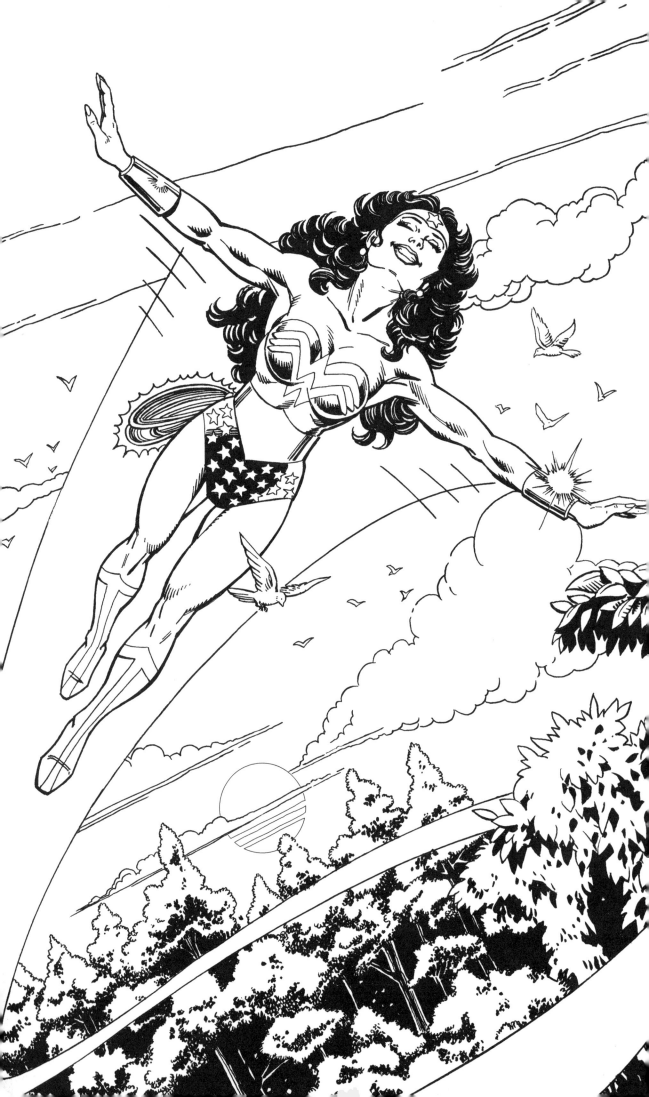

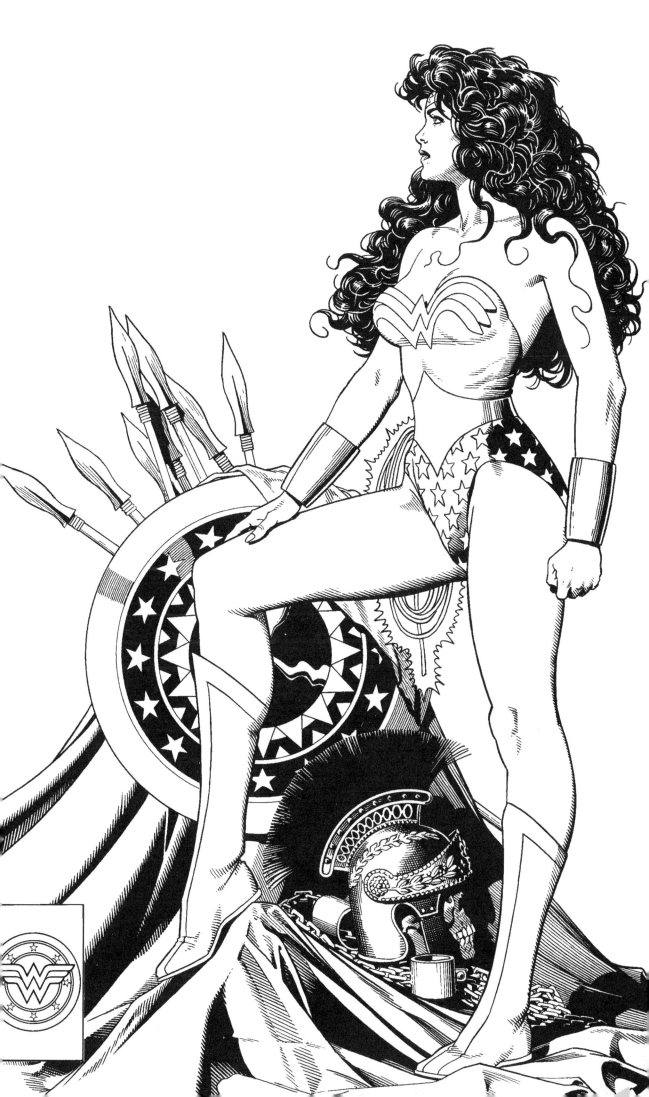

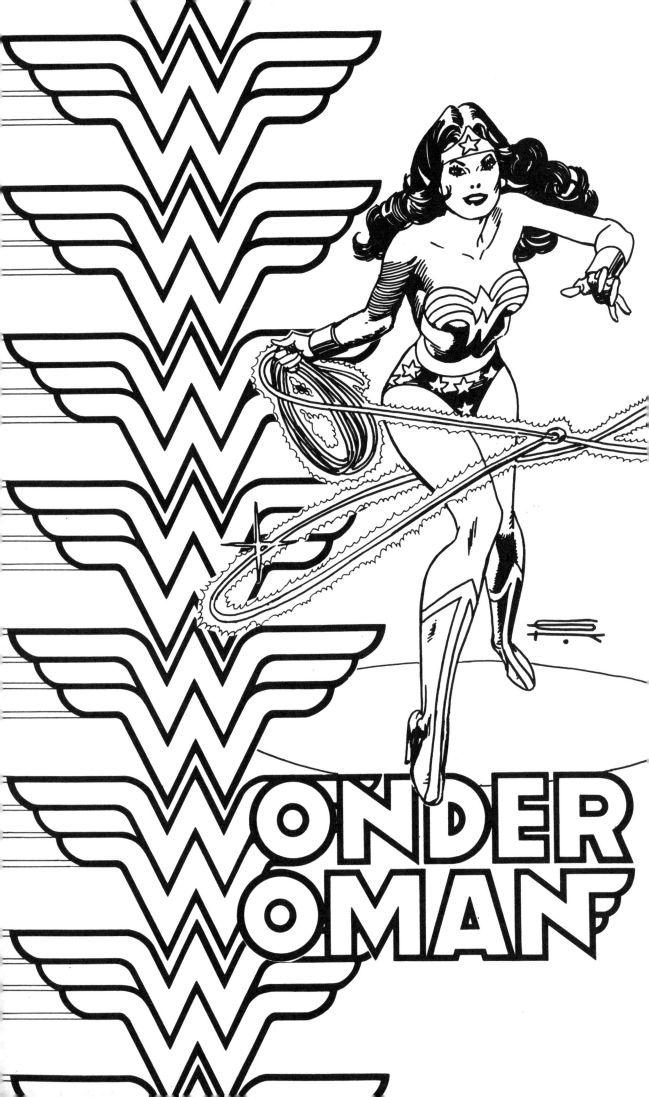

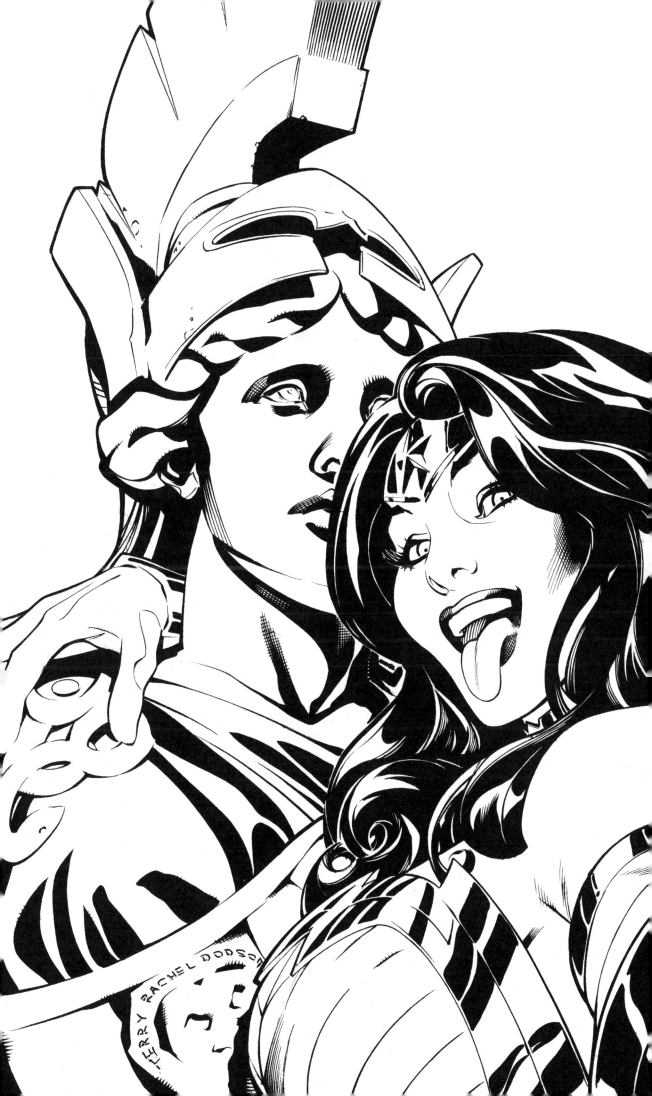

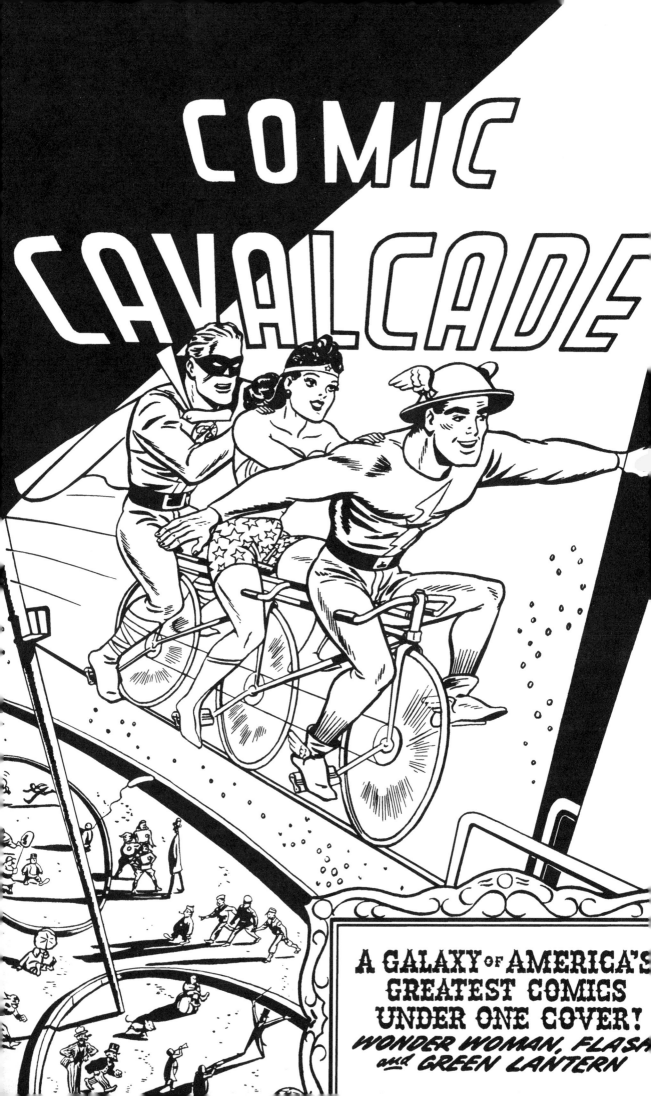

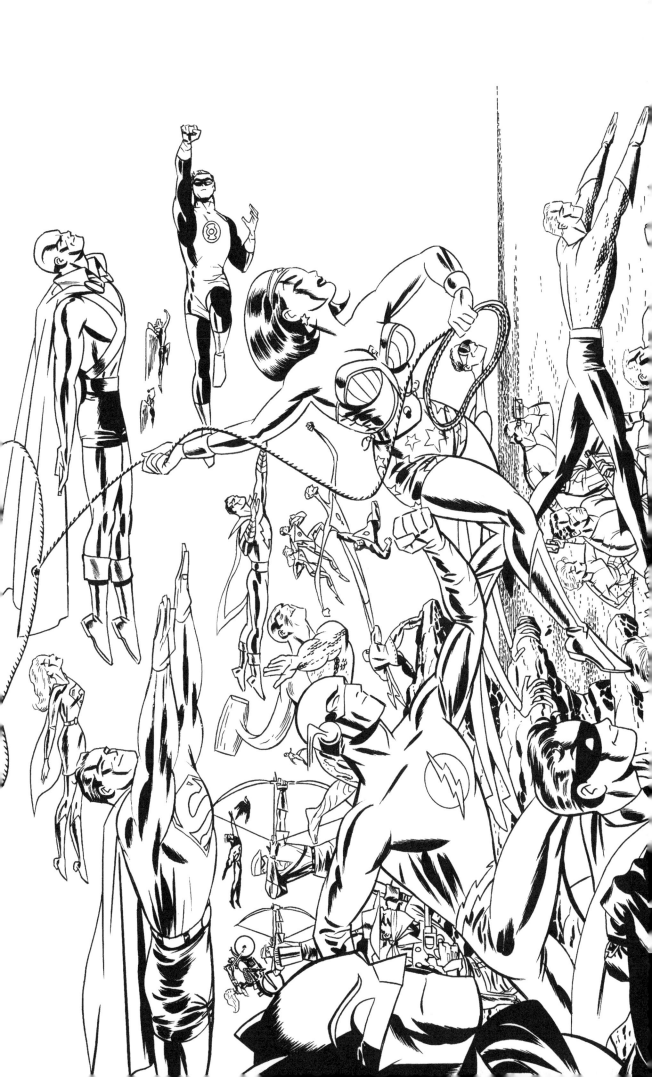

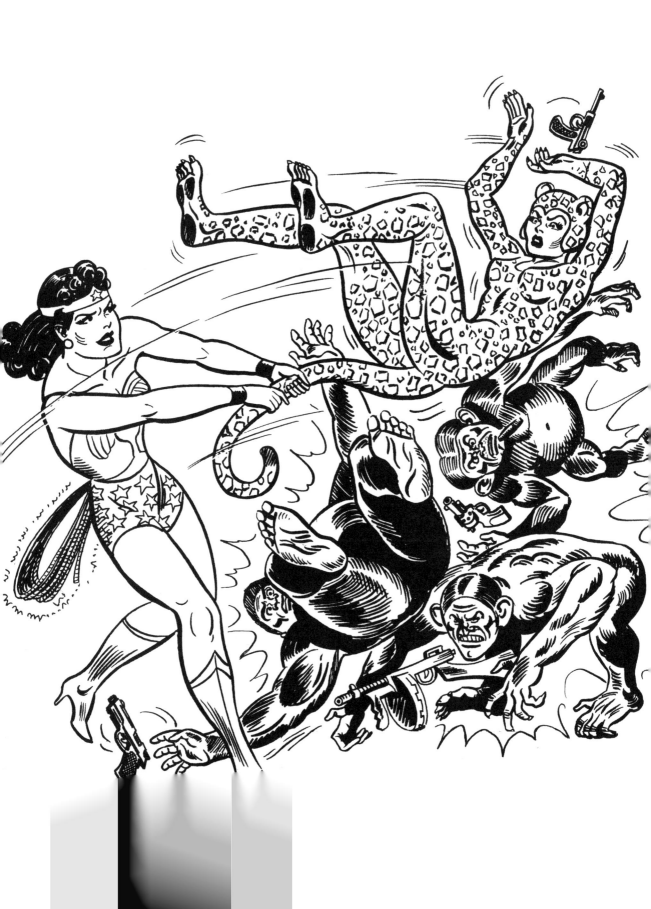

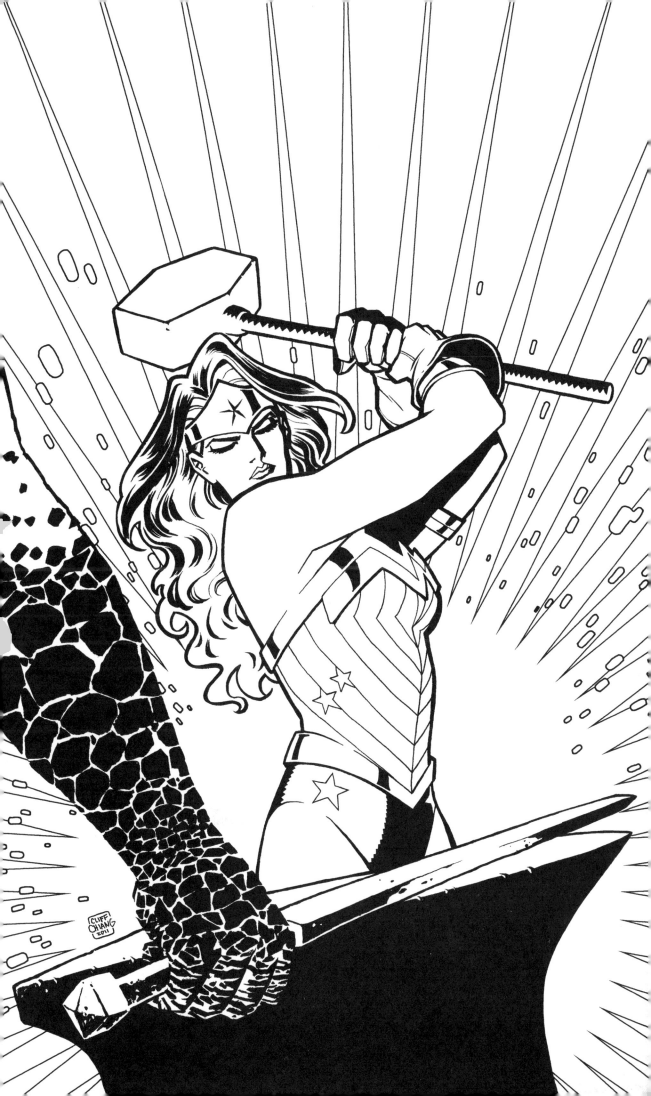

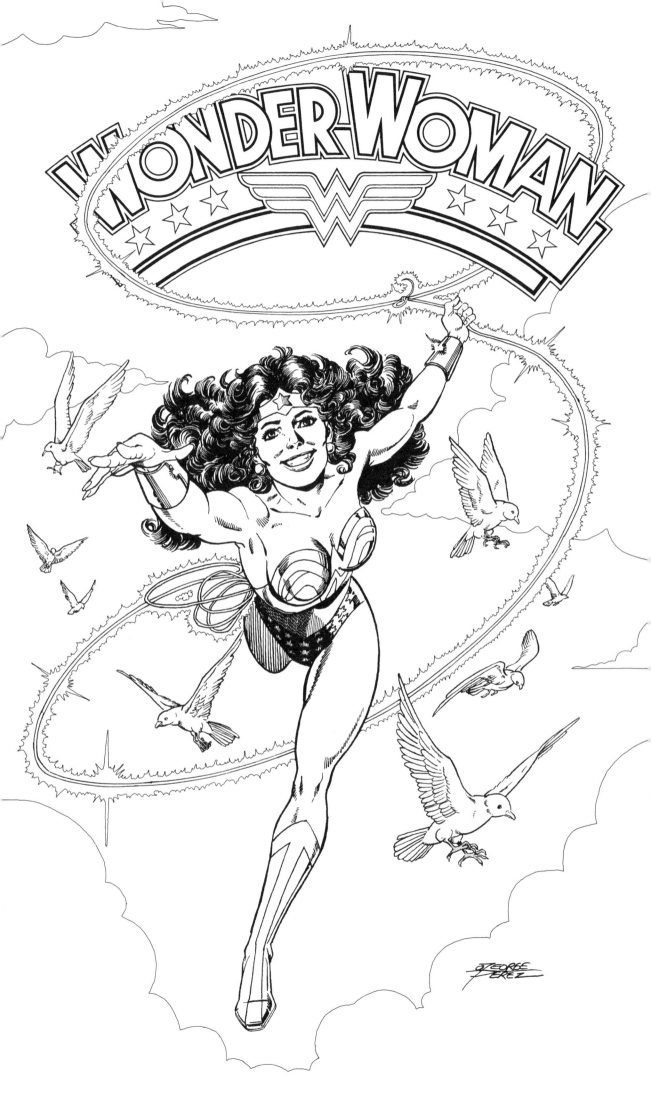

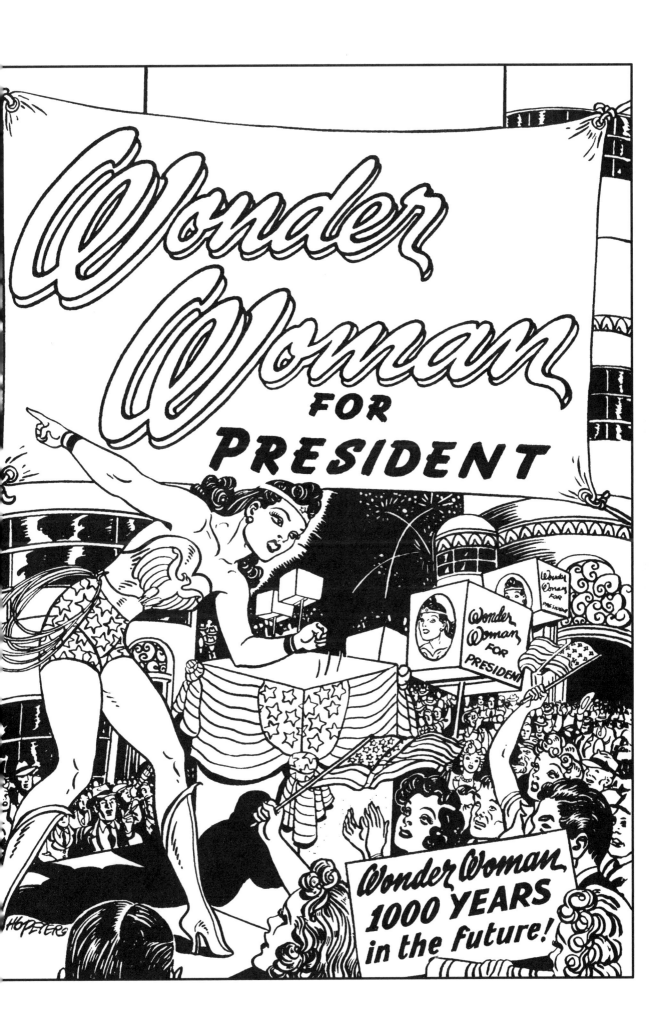

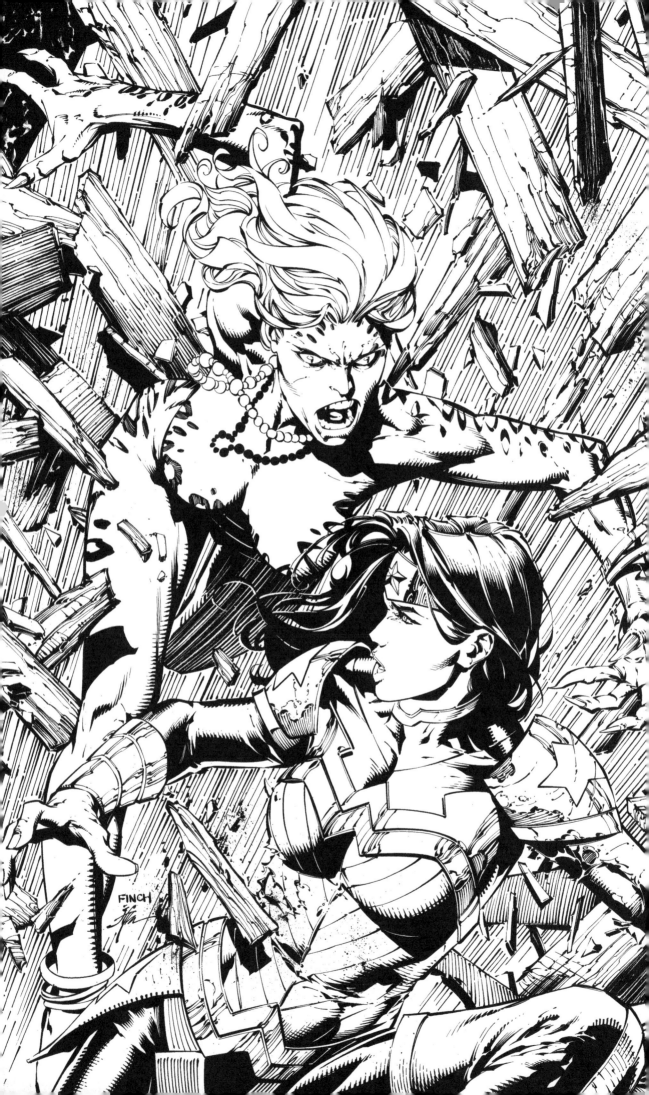

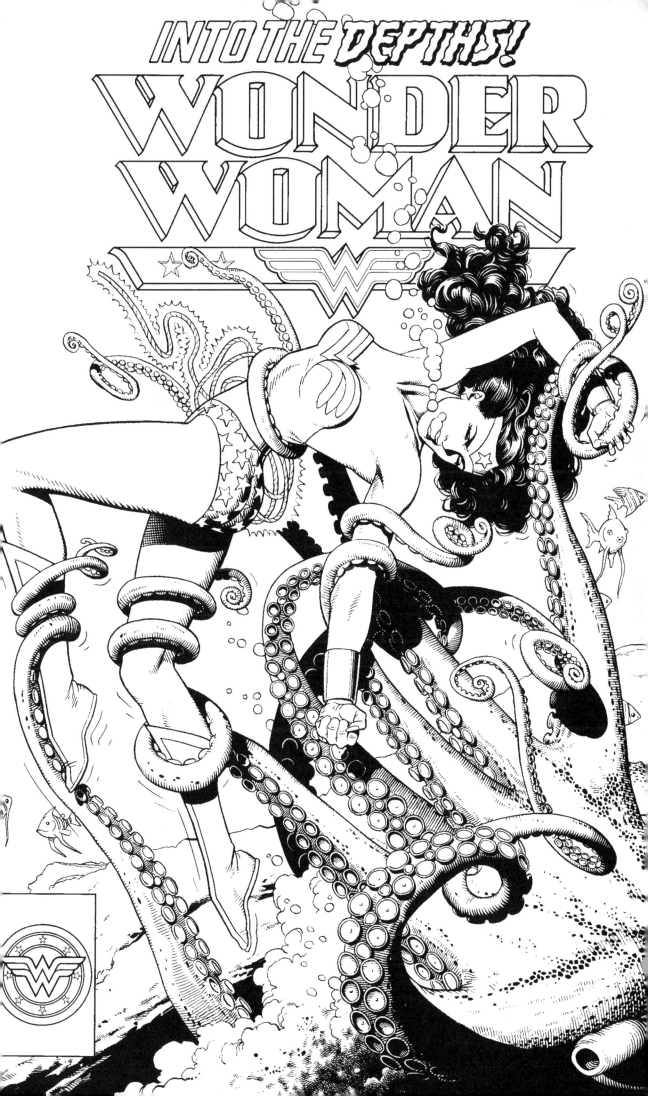

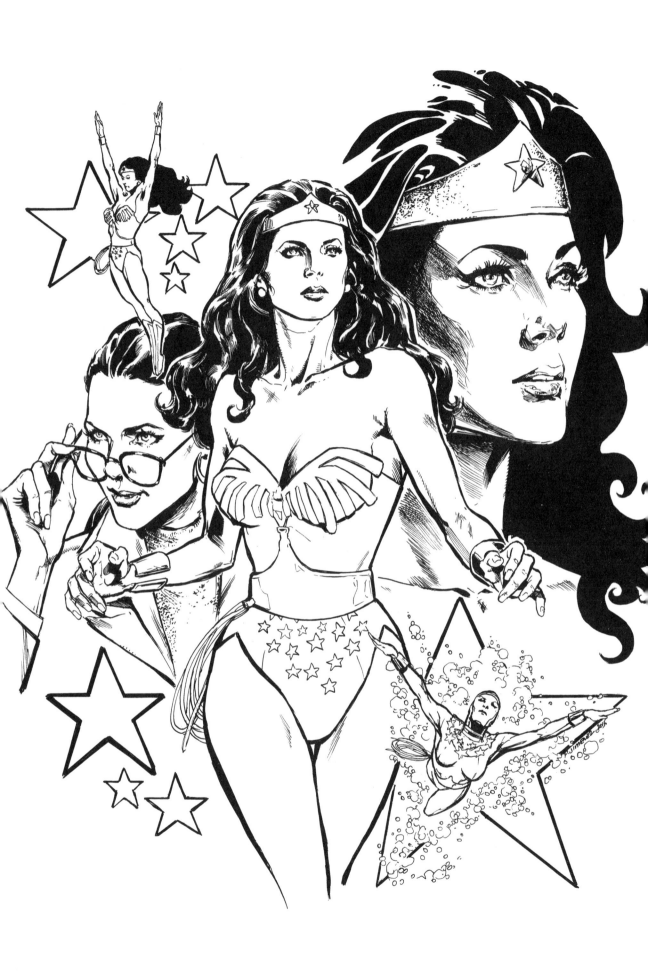

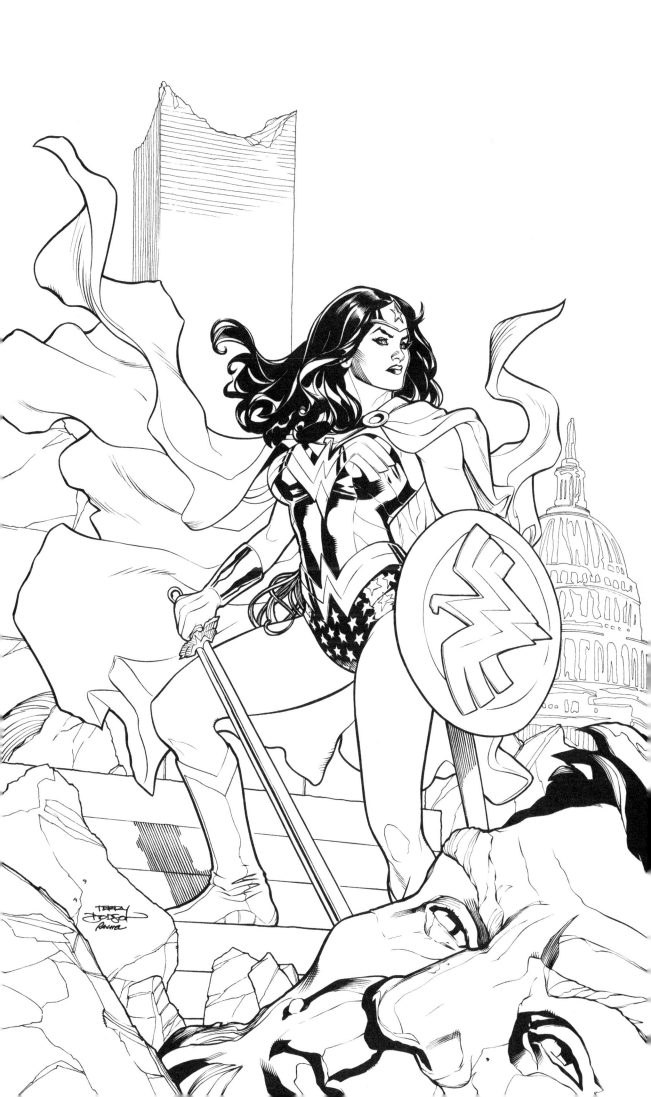

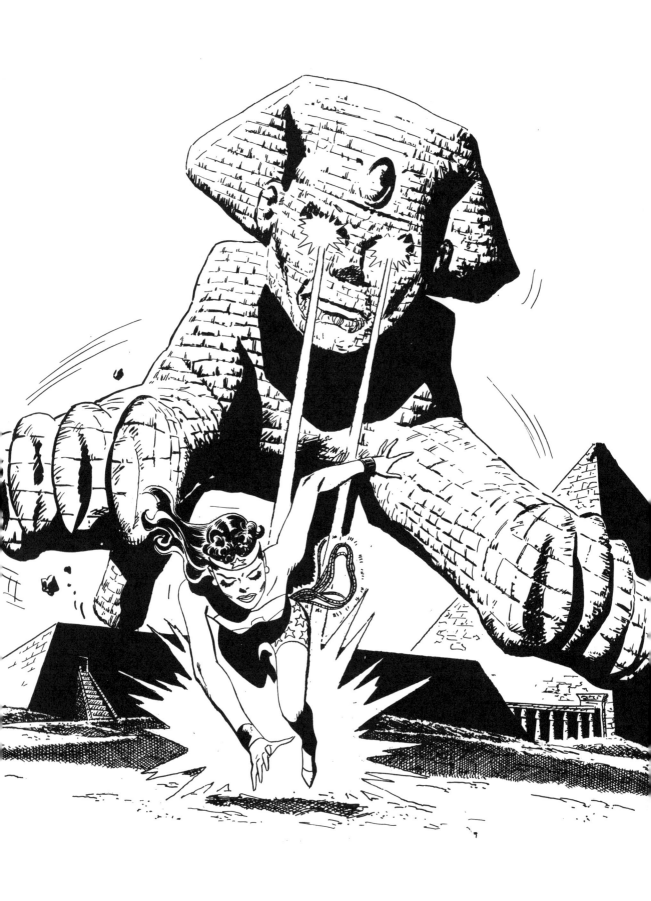

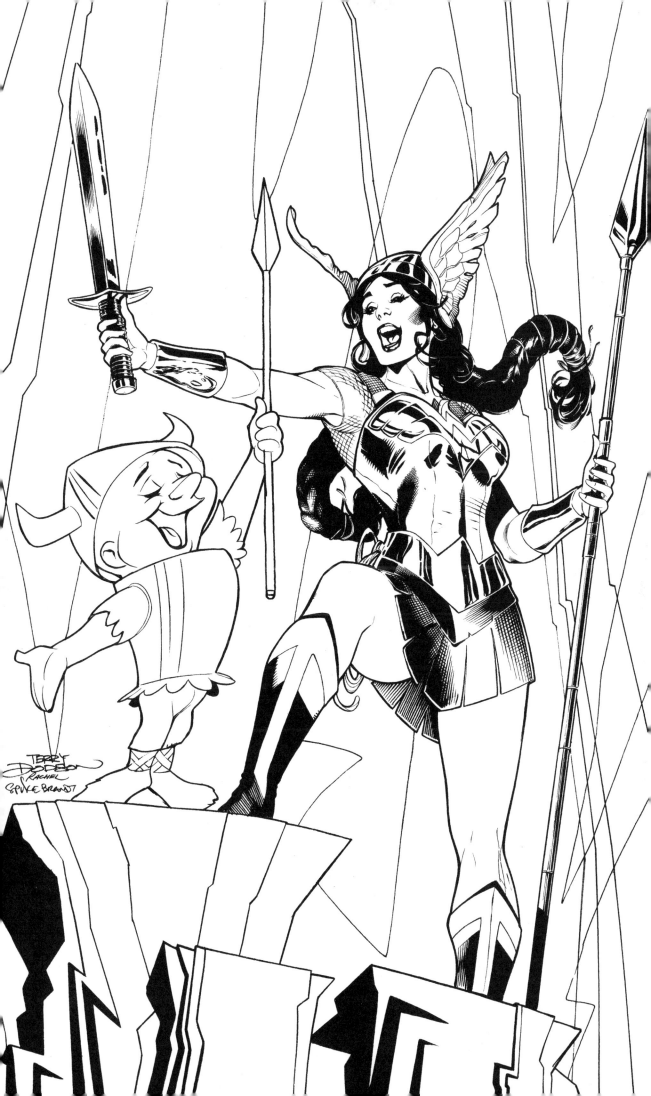

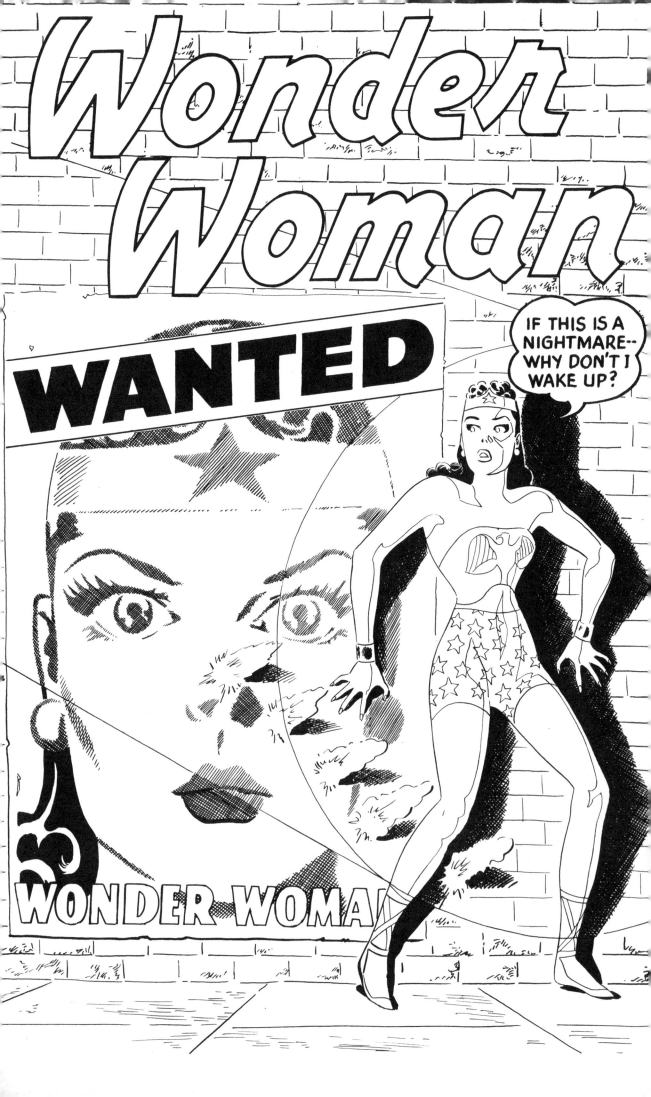

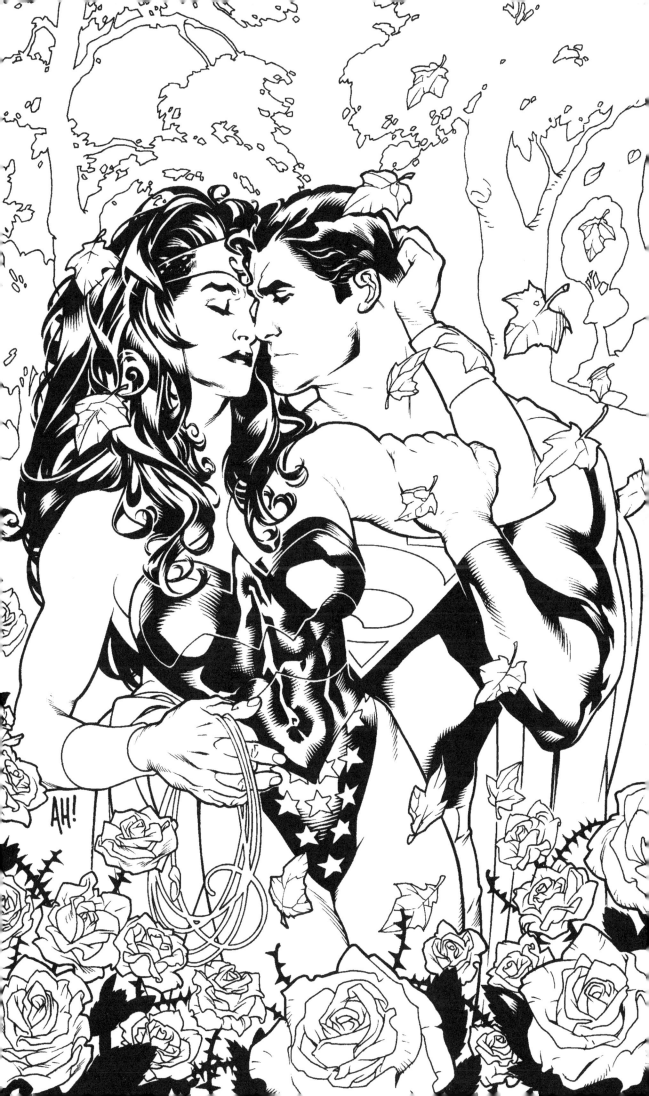

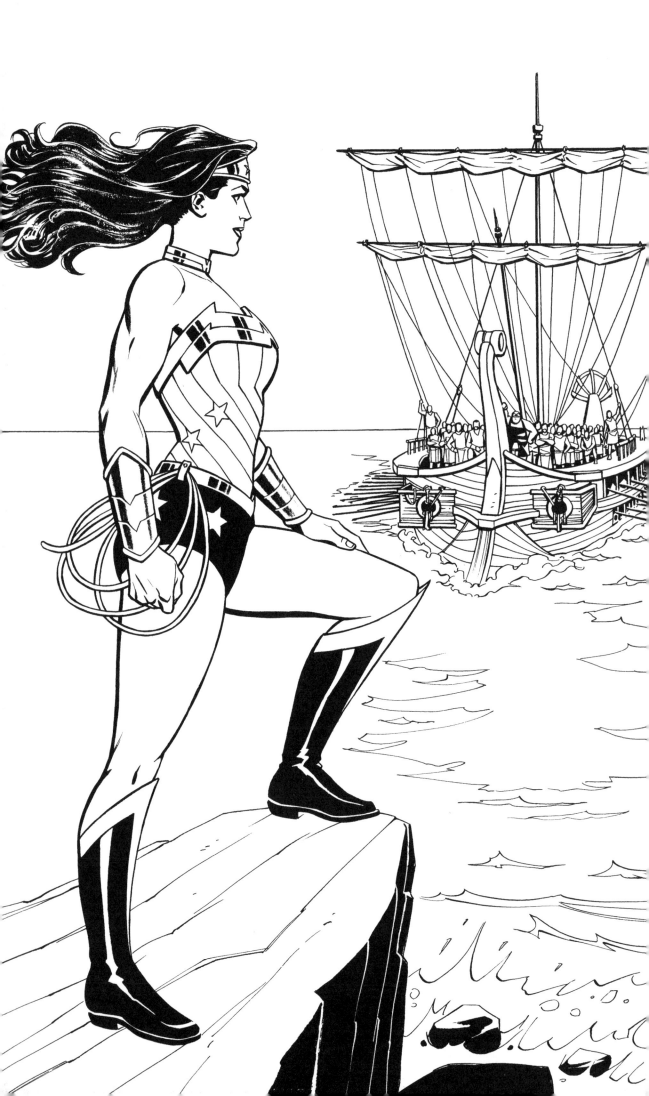

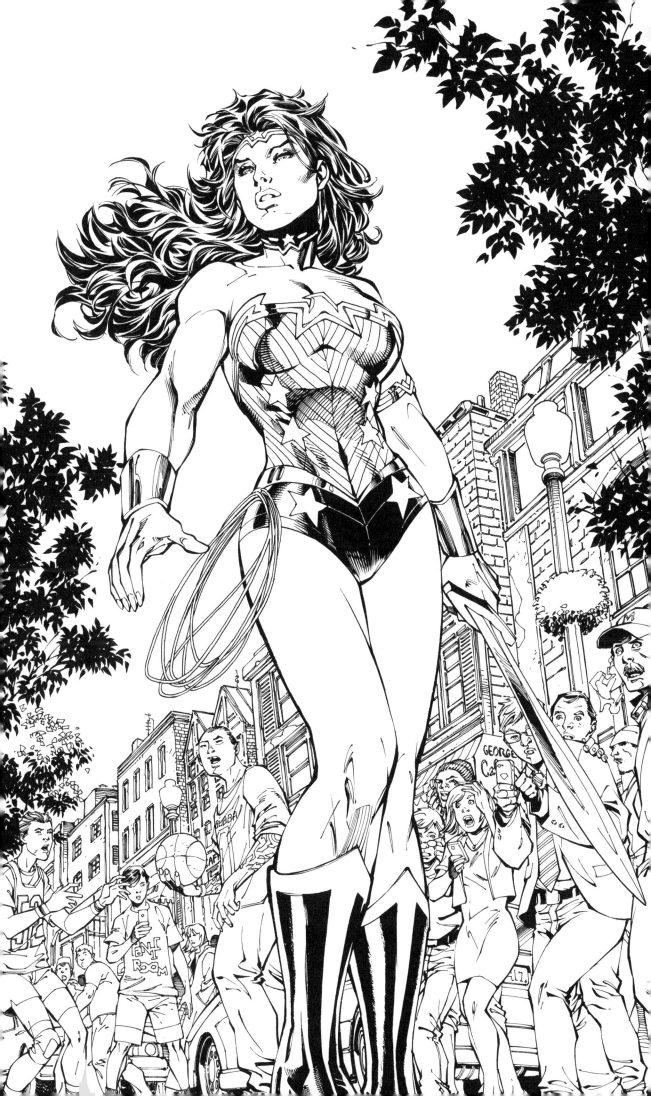

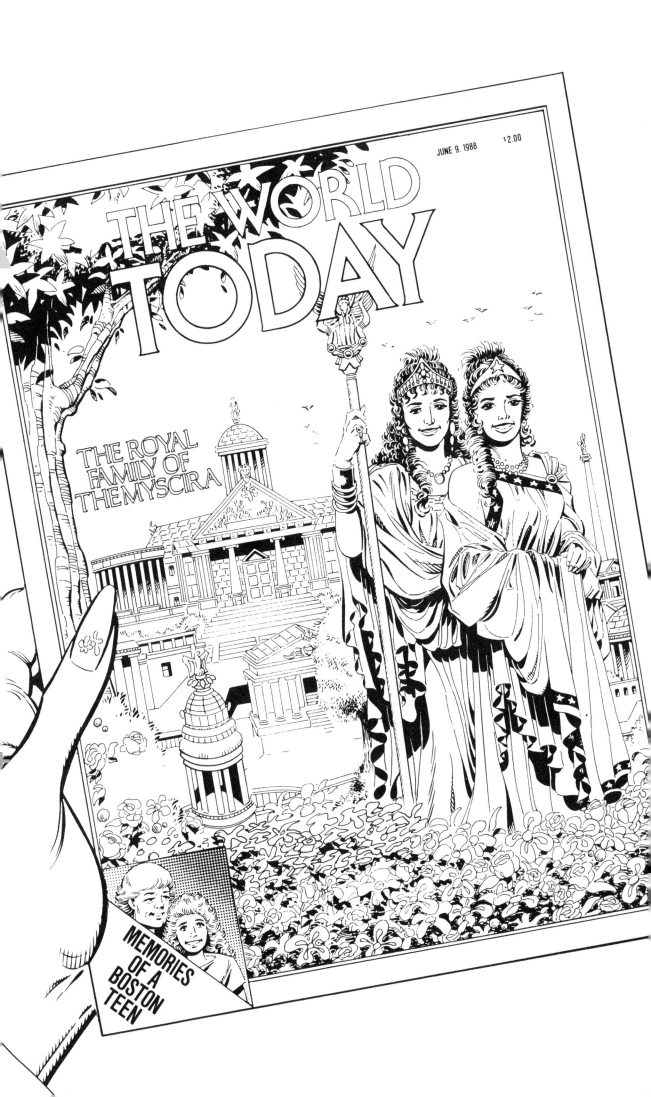

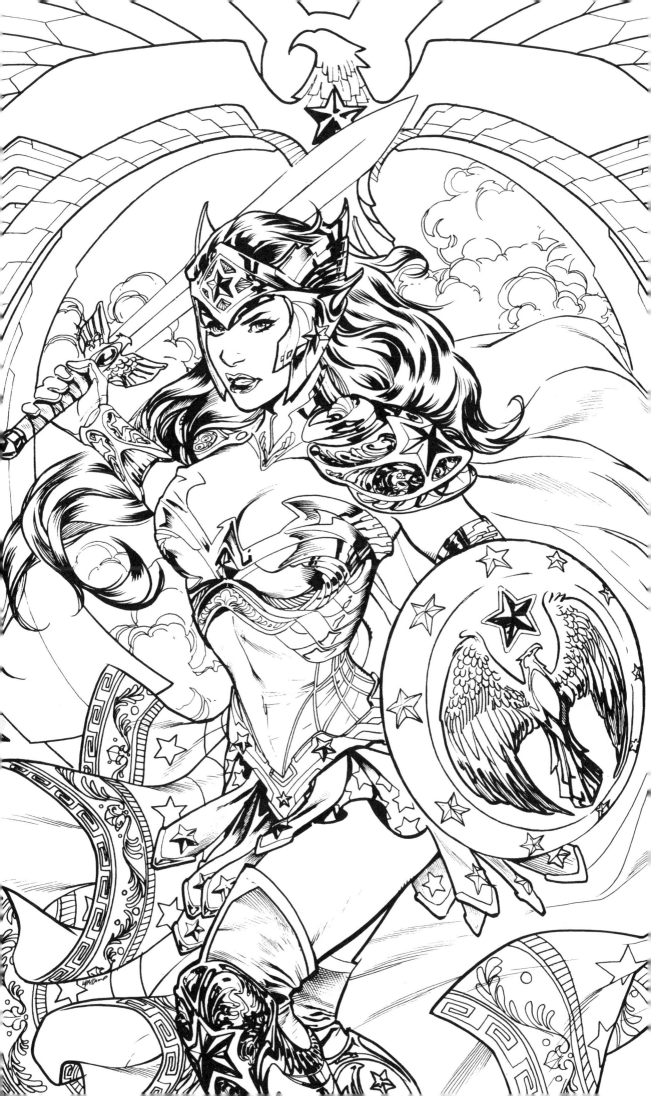

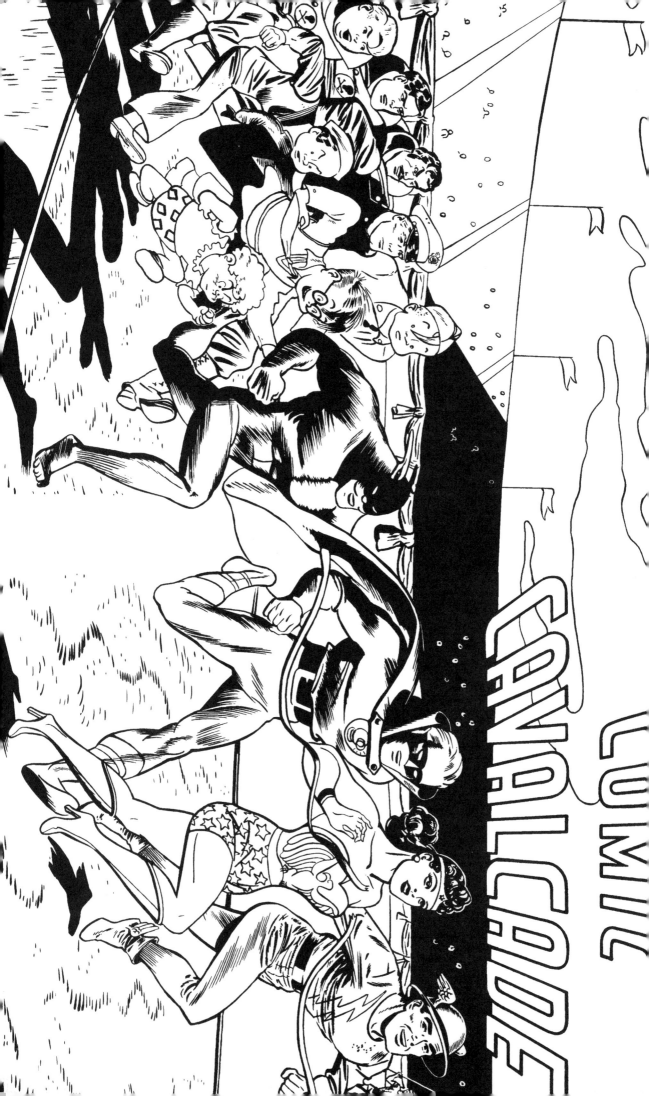

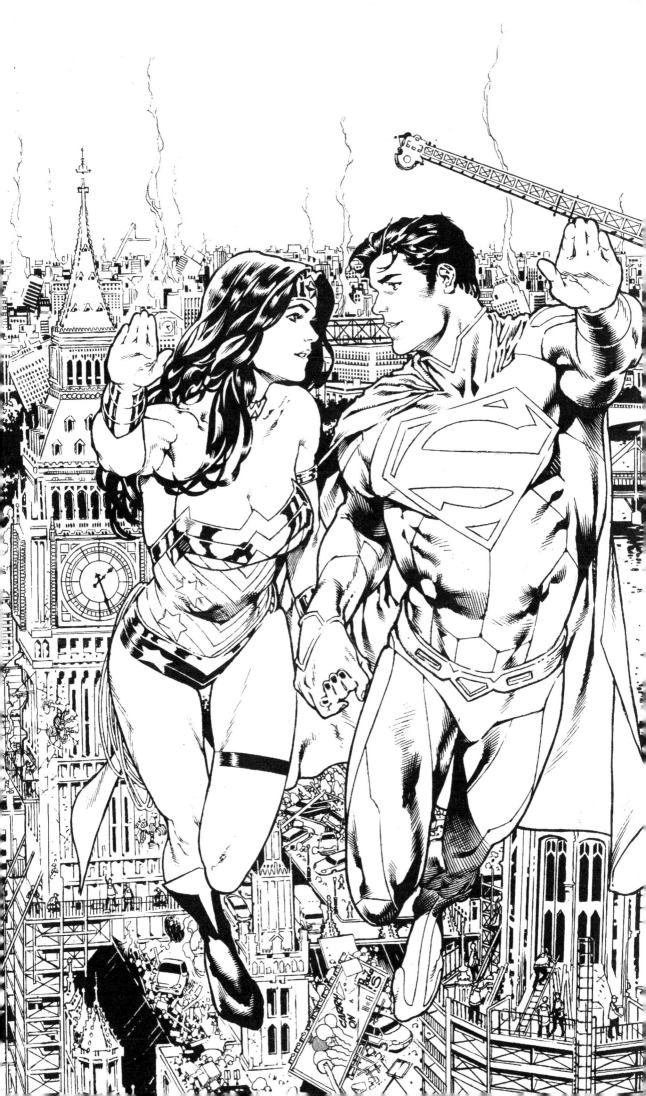

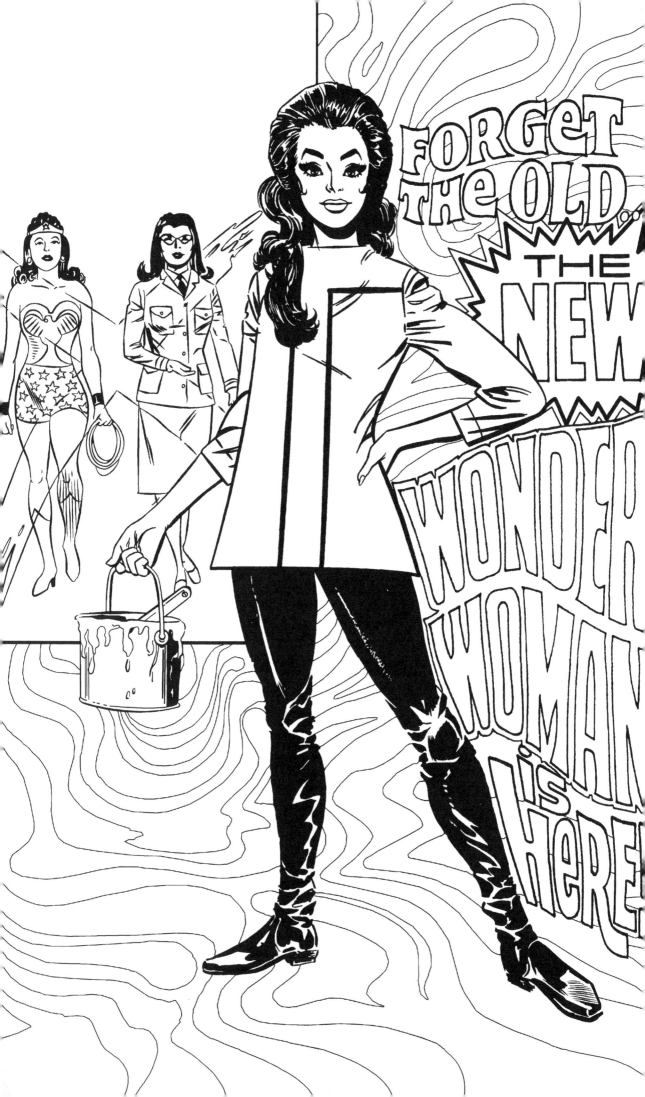

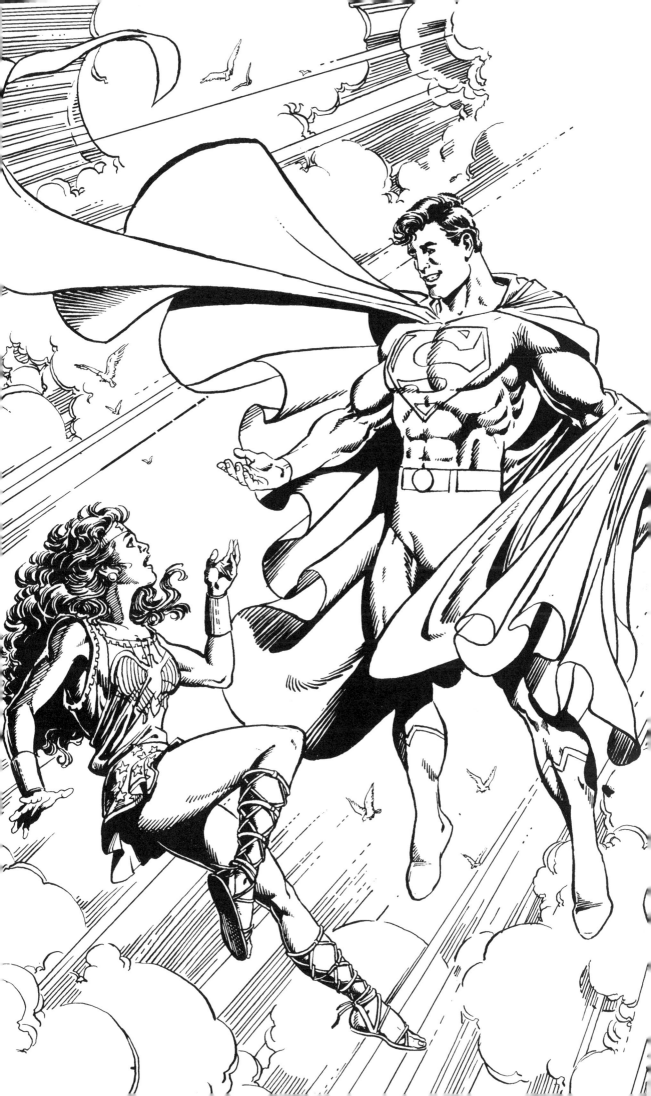

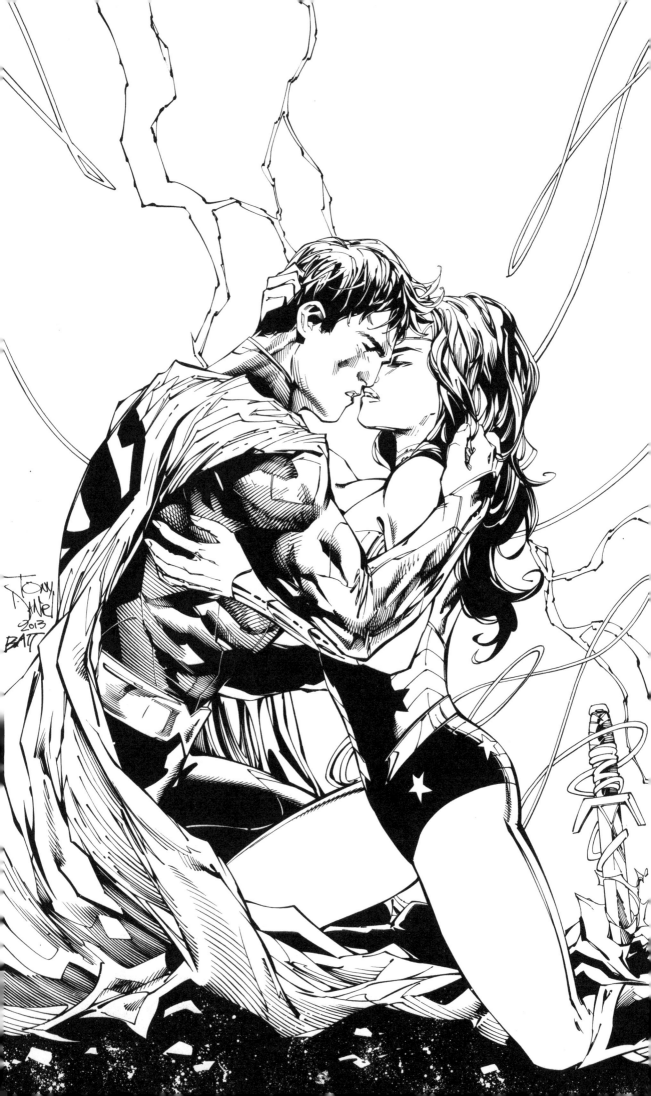

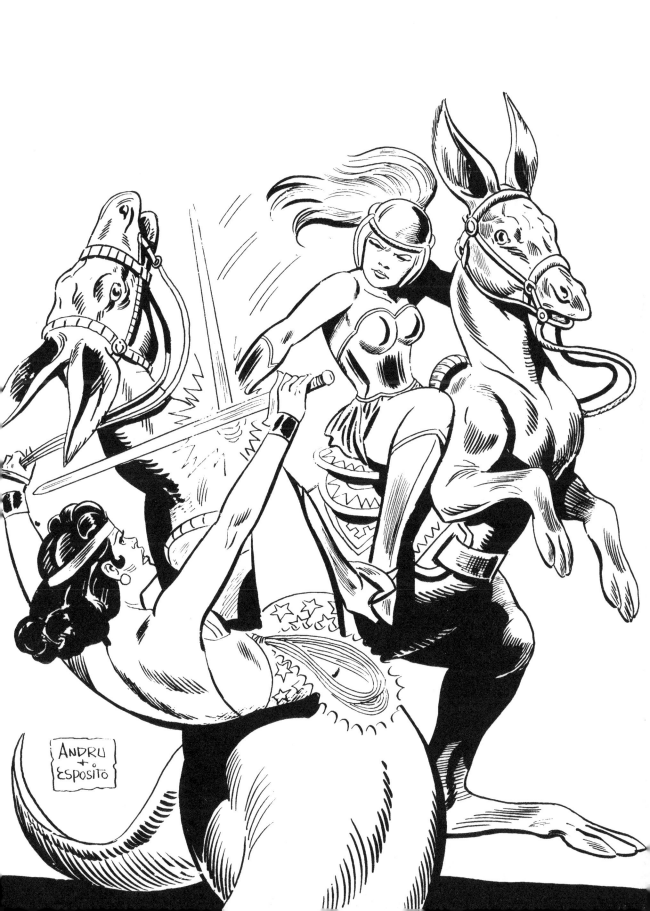

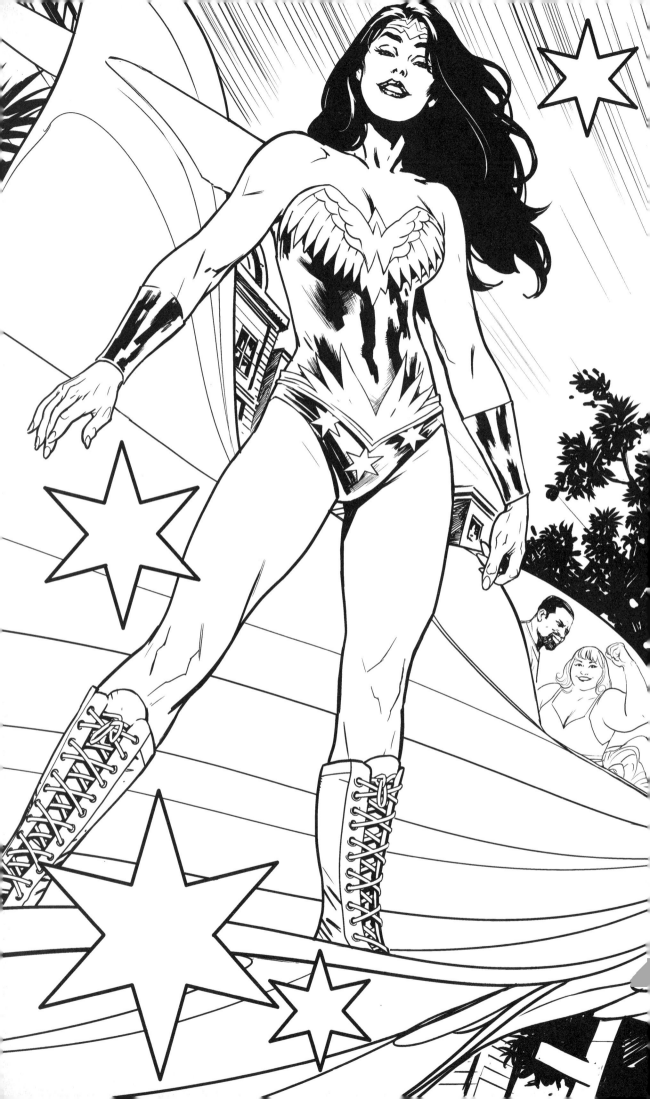

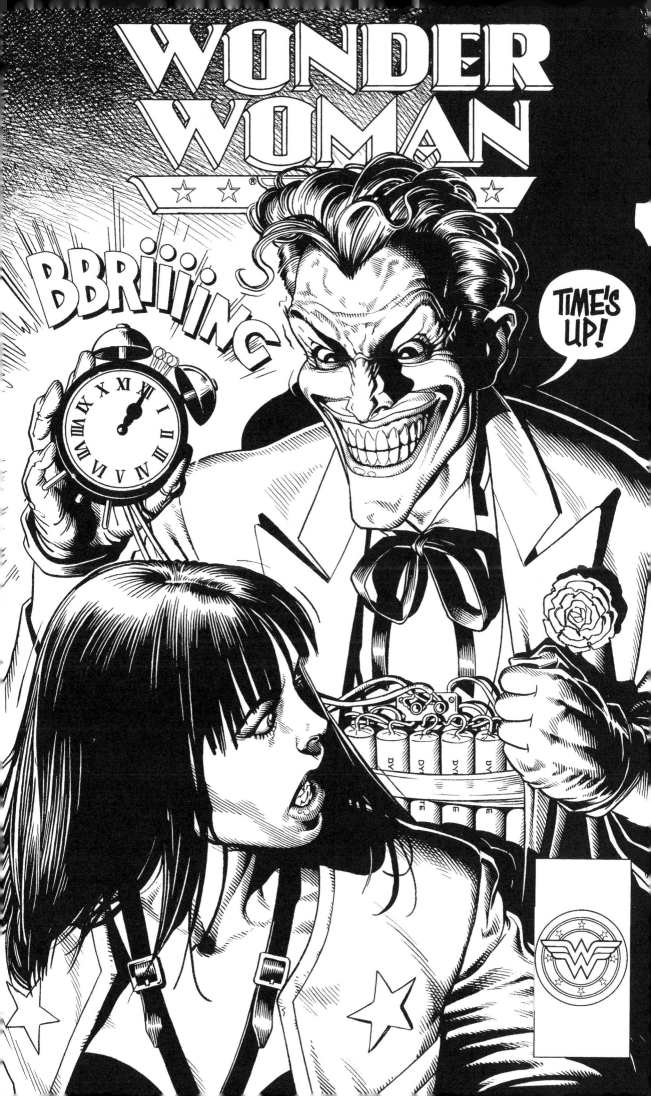

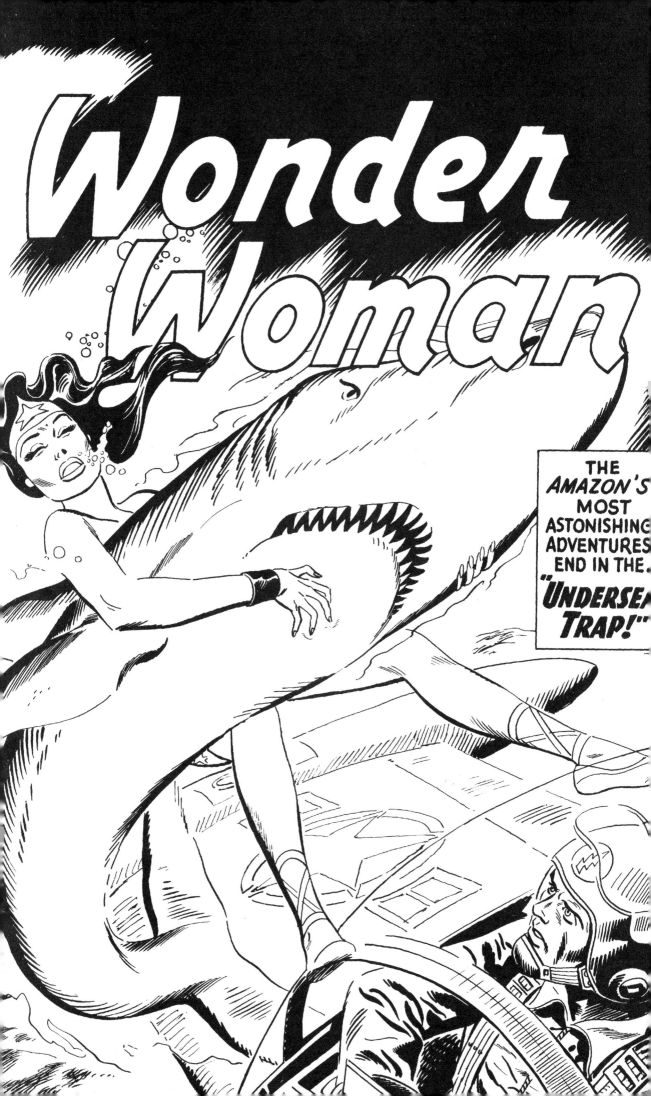

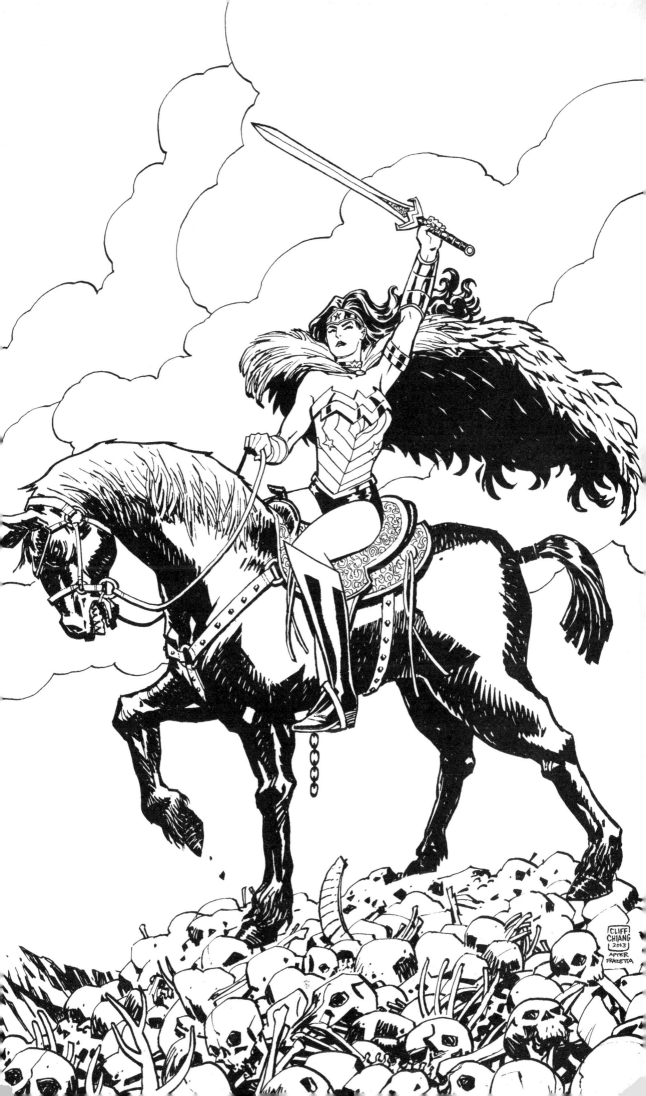

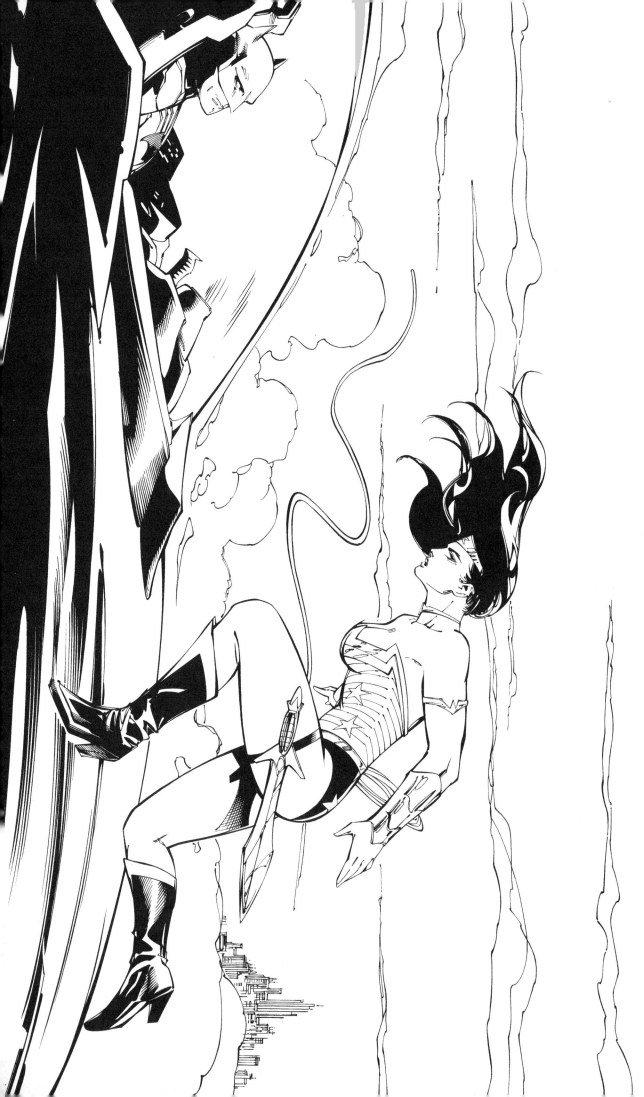

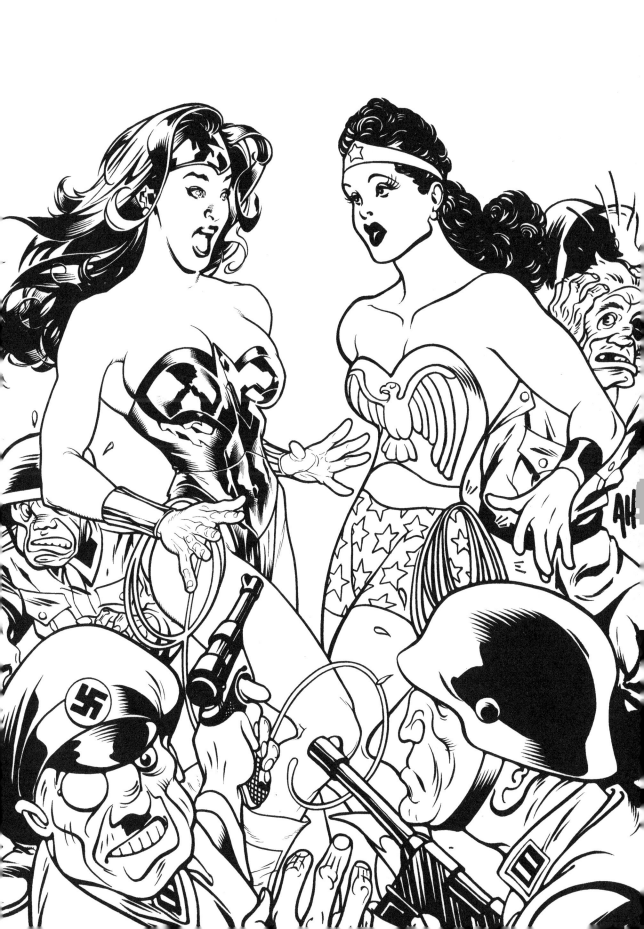

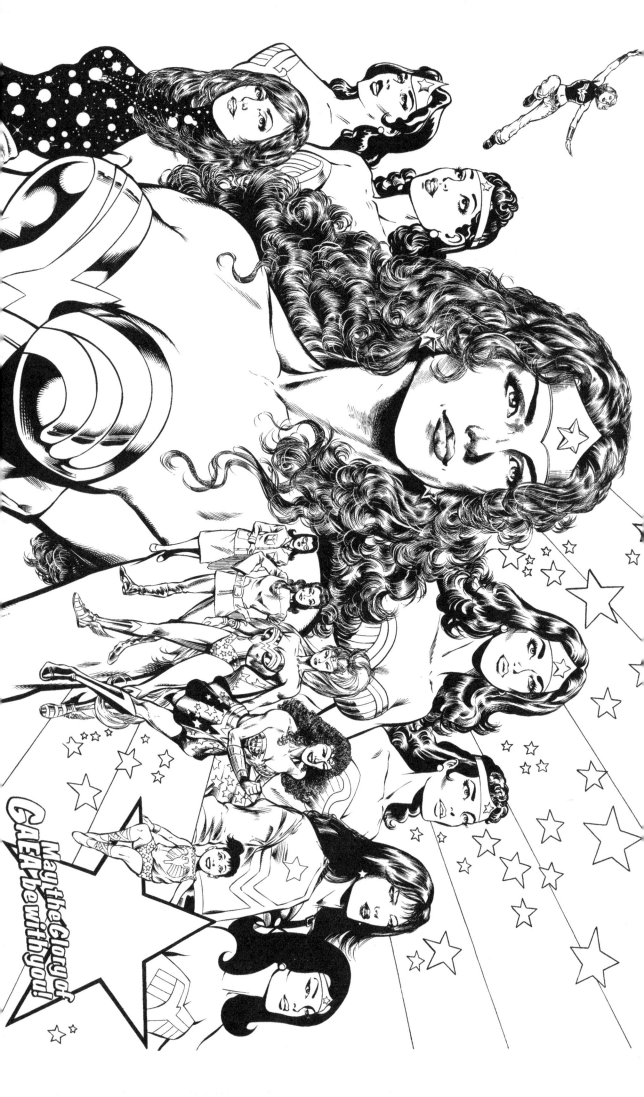

May the Glory of GAEA be with you!

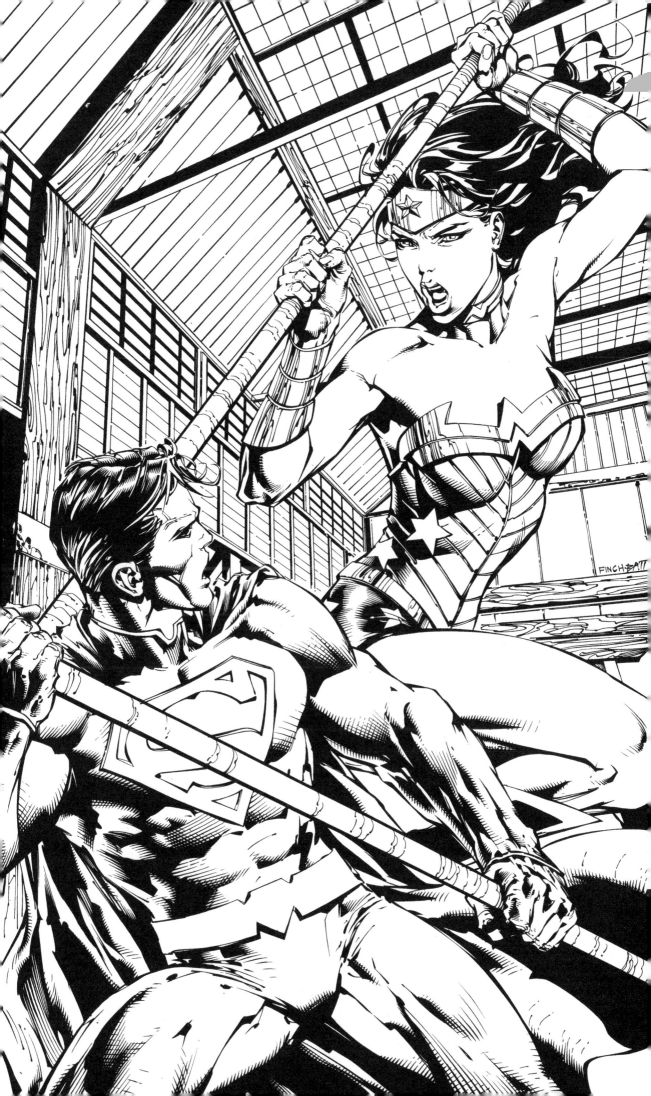

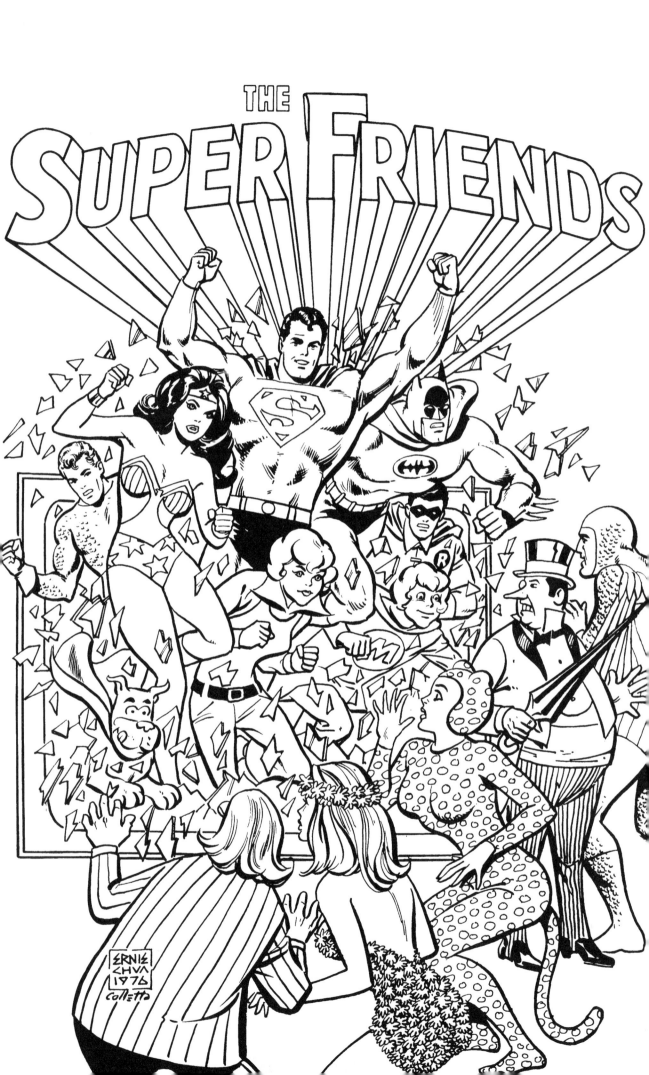

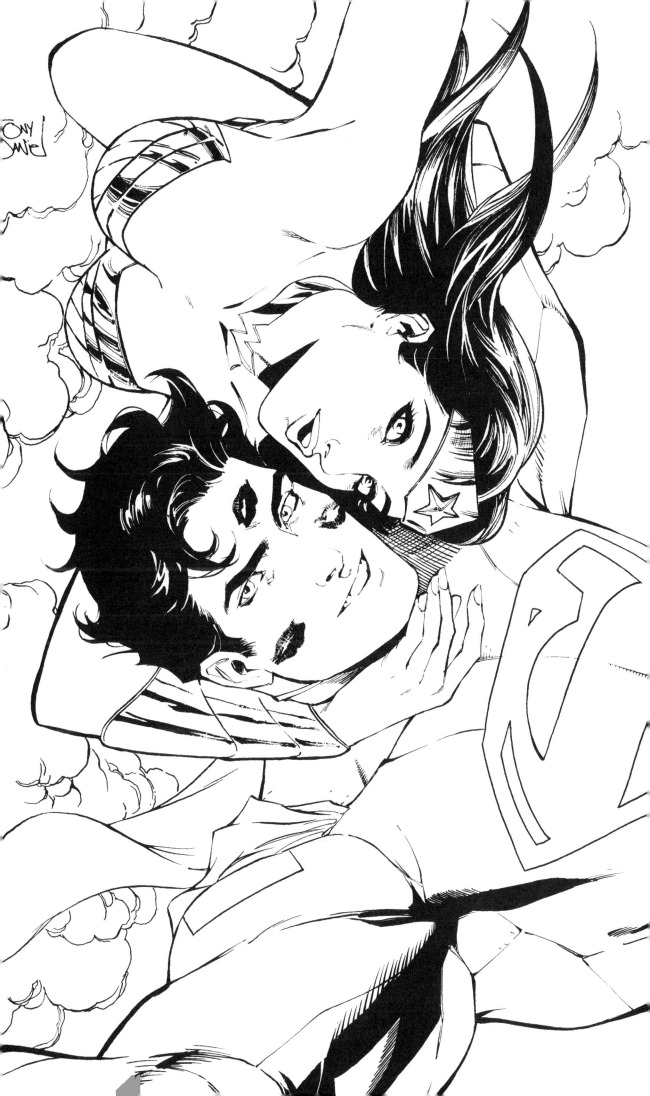

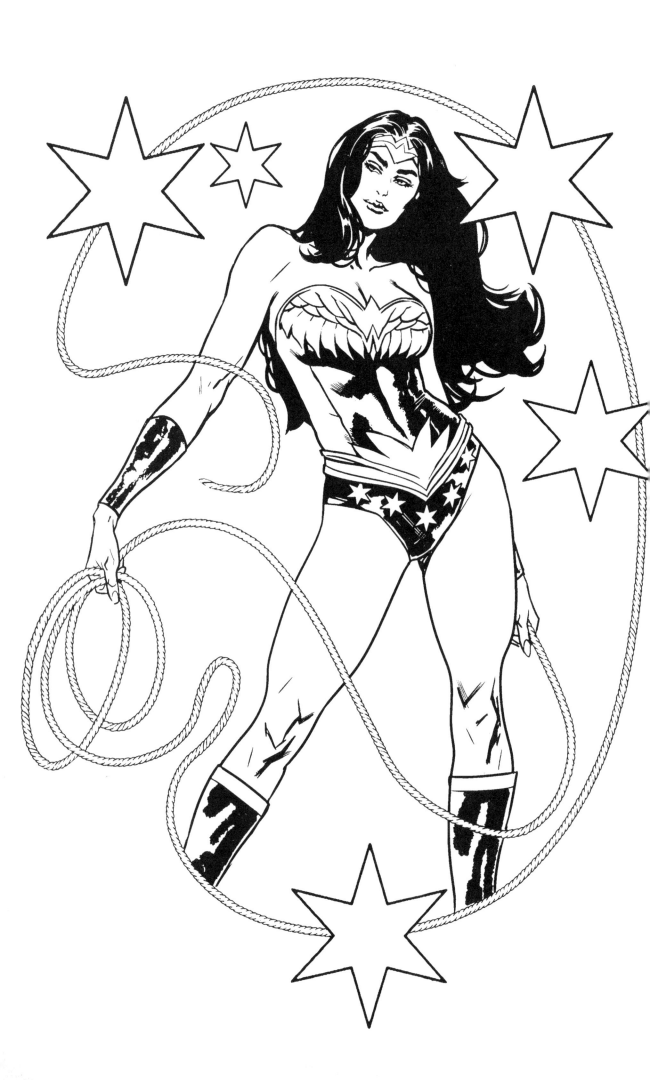

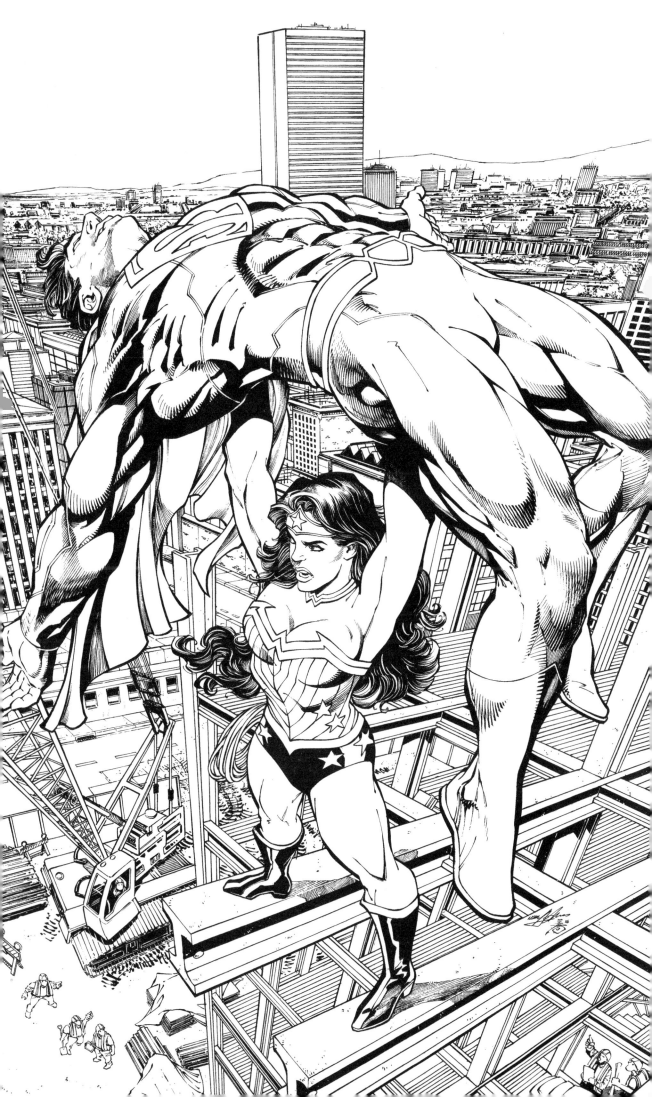

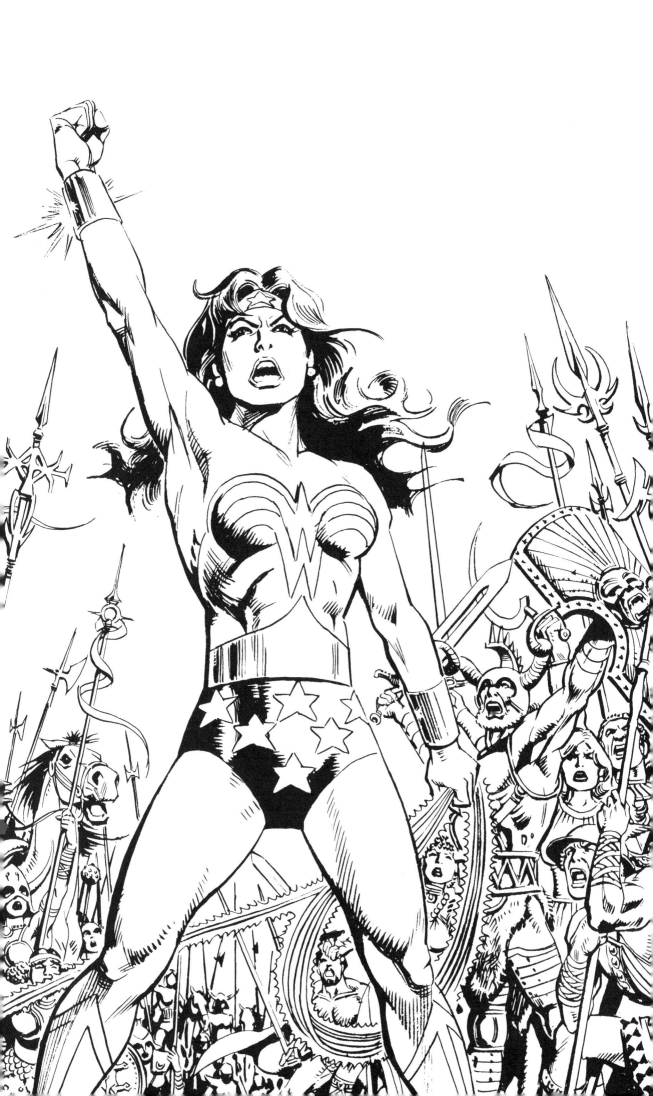

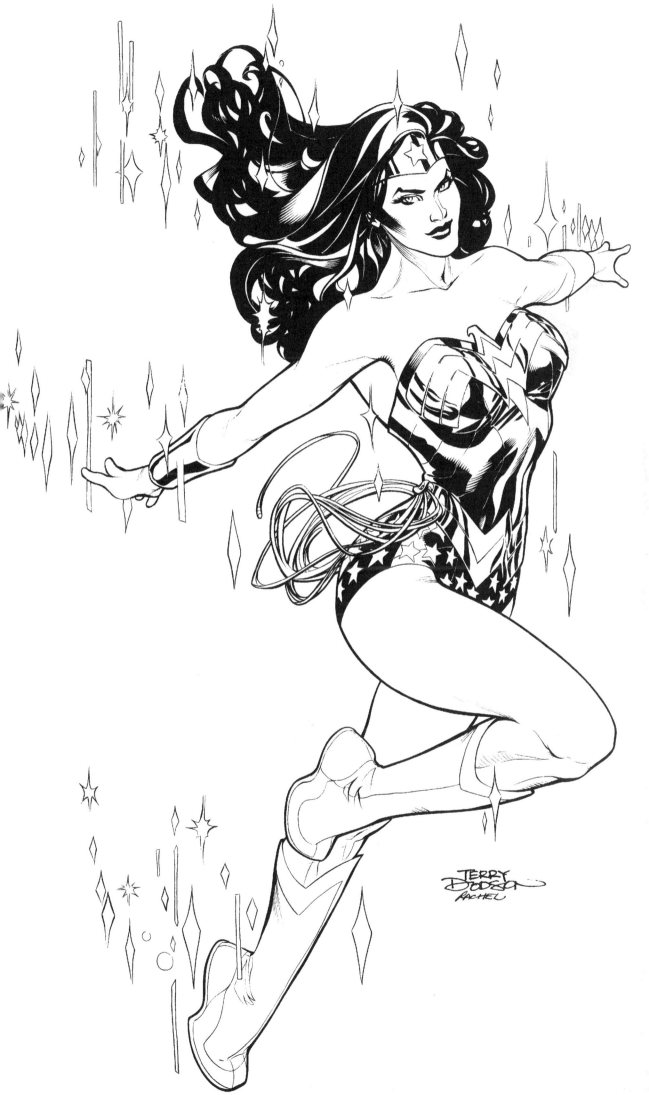

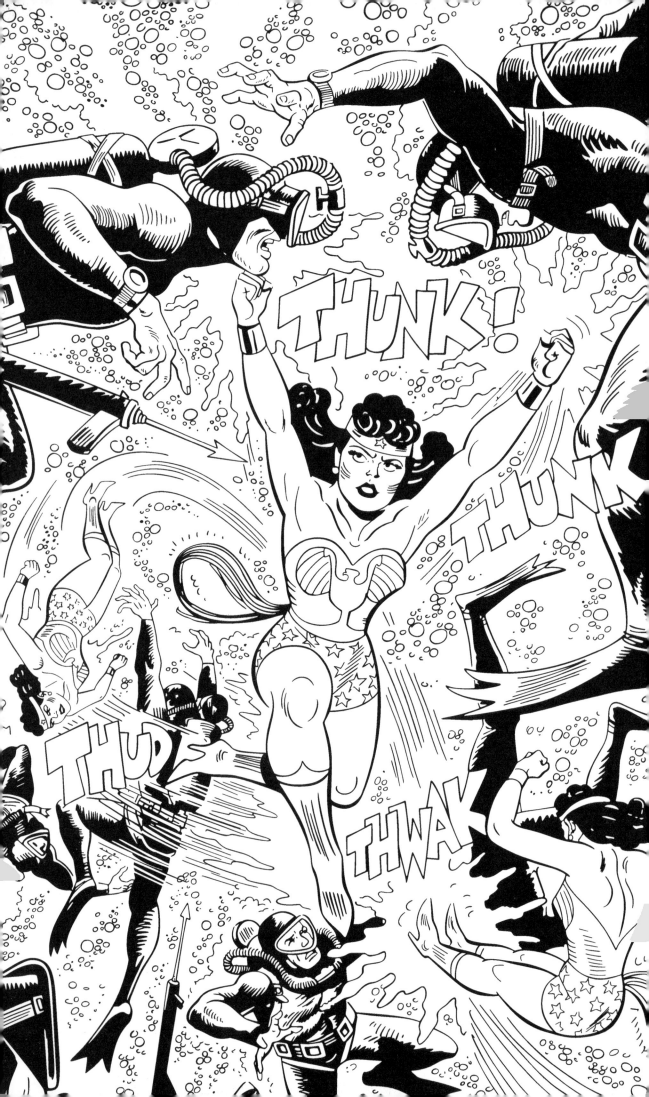

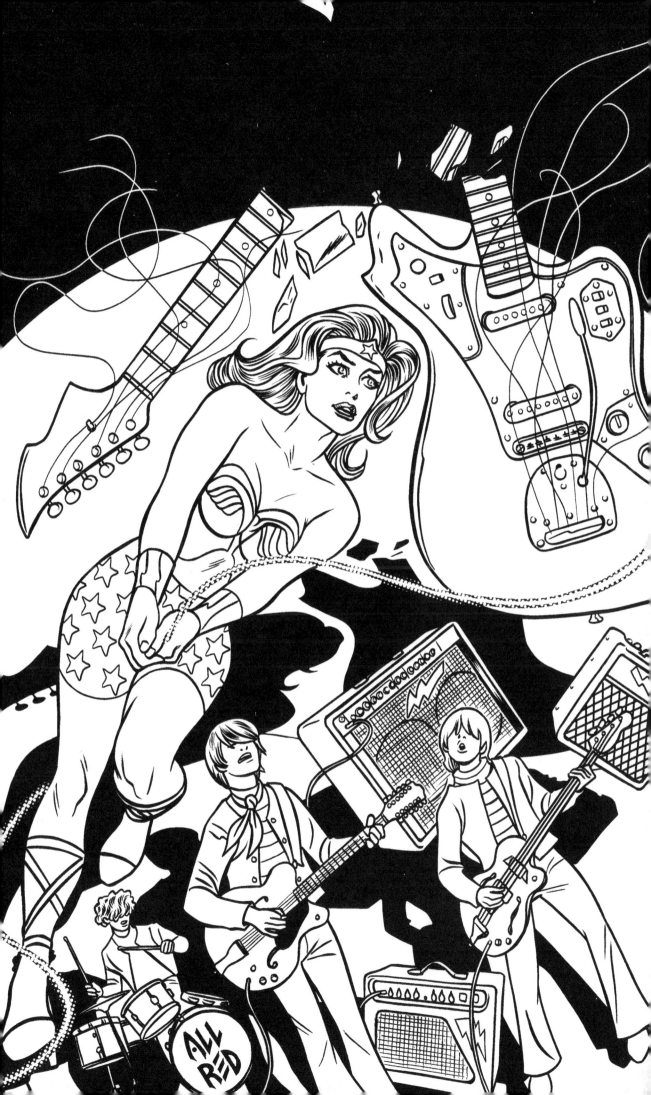

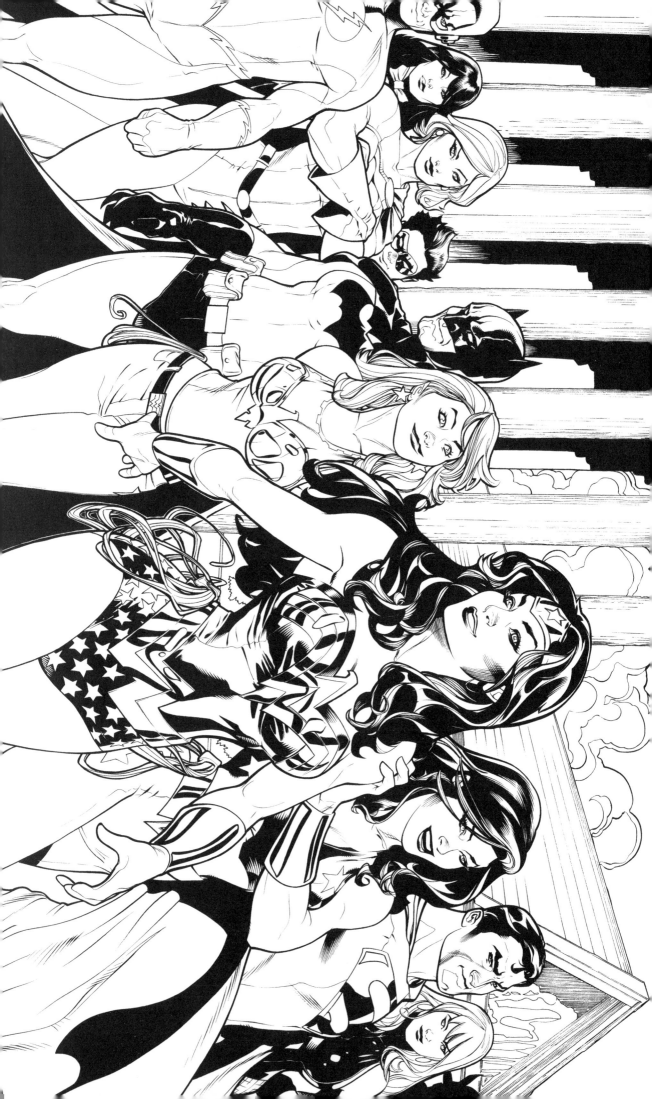

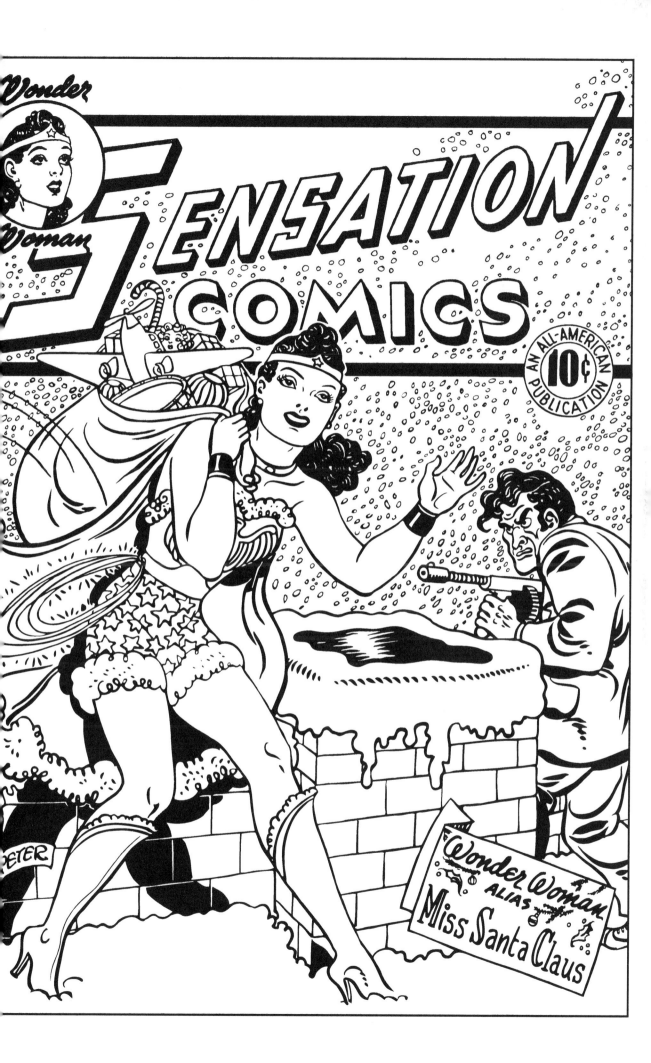

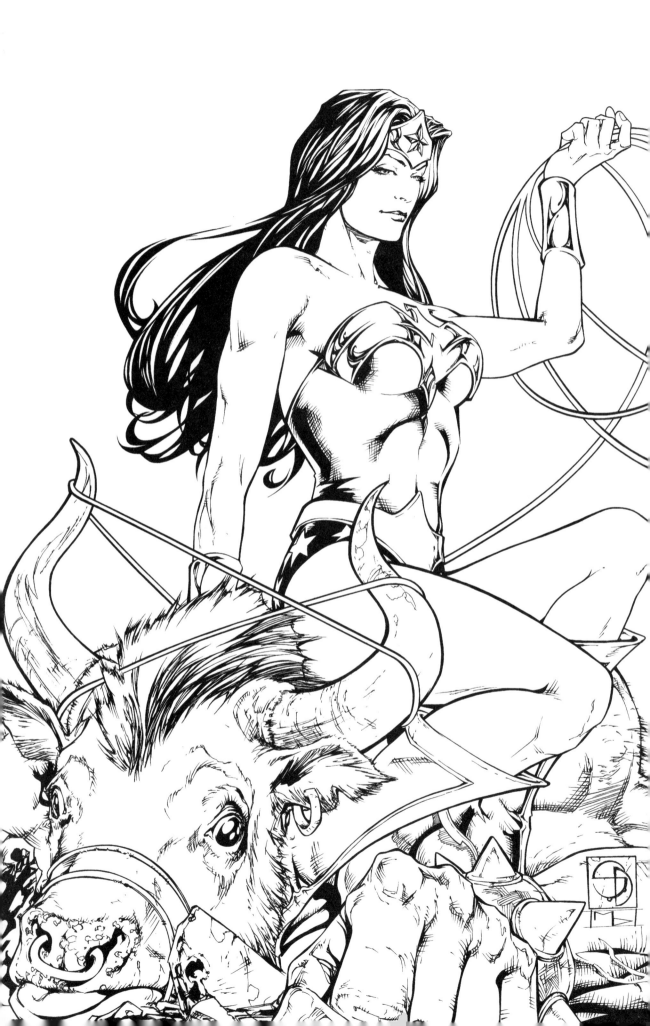

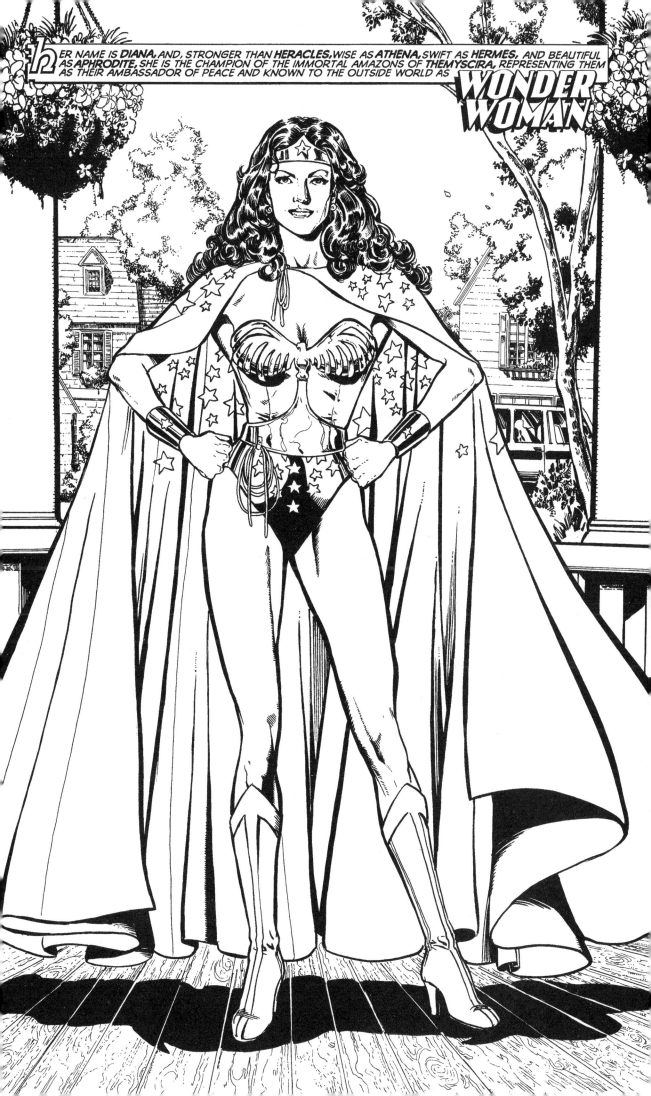

ER NAME IS **DIANA**, AND, STRONGER THAN **HERACLES**, WISE AS **ATHENA**, SWIFT AS **HERMES**, AND BEAUTIFUL AS **APHRODITE**, SHE IS THE CHAMPION OF THE IMMORTAL AMAZONS OF **THEMYSCIRA**, REPRESENTING THEM AS THEIR AMBASSADOR OF PEACE AND KNOWN TO THE OUTSIDE WORLD AS

WONDER WOMAN

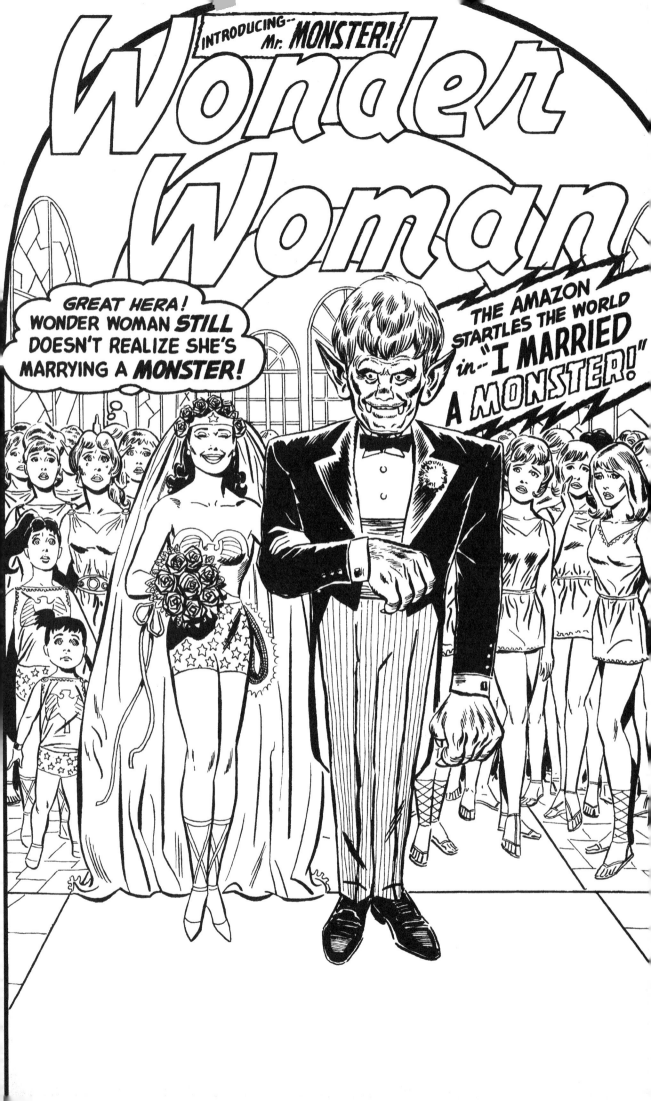

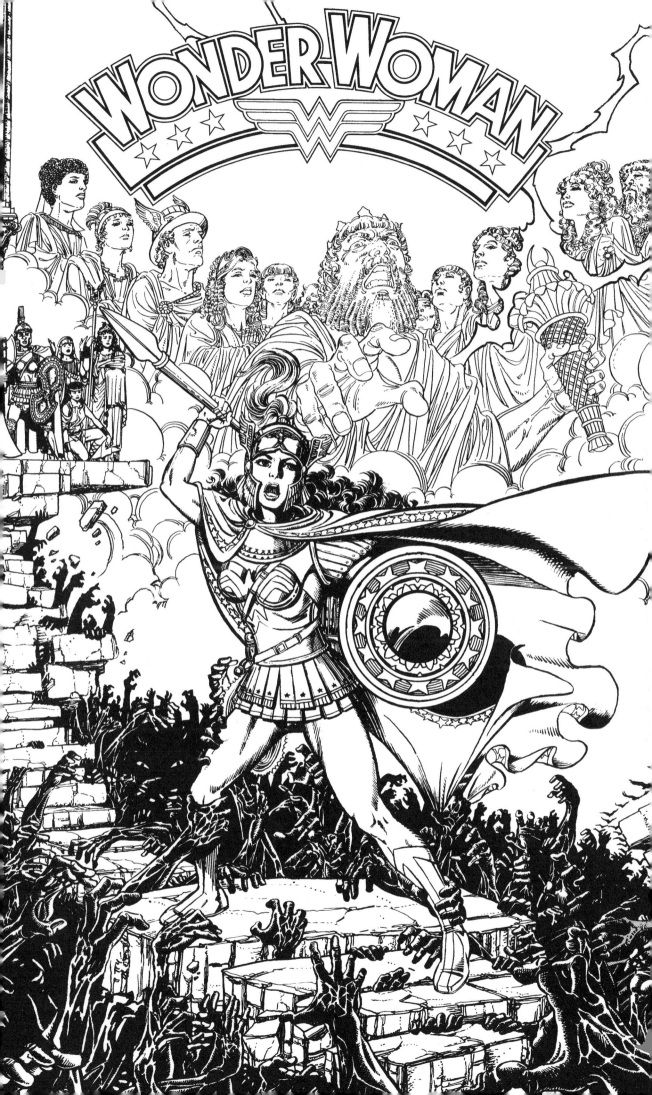

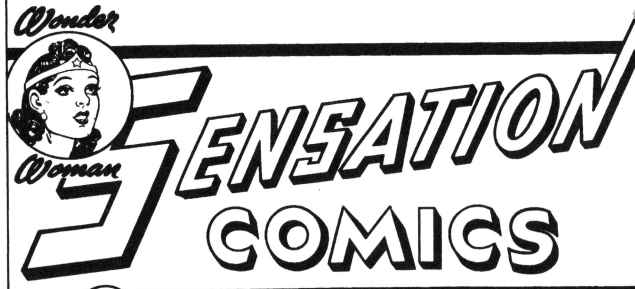

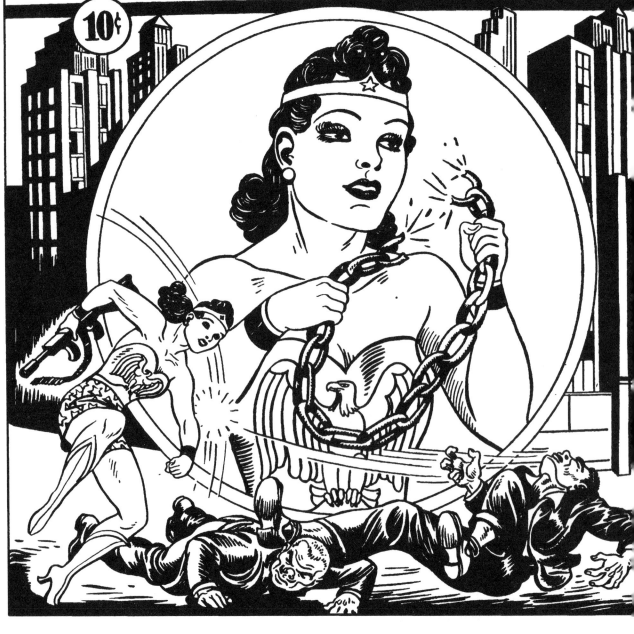

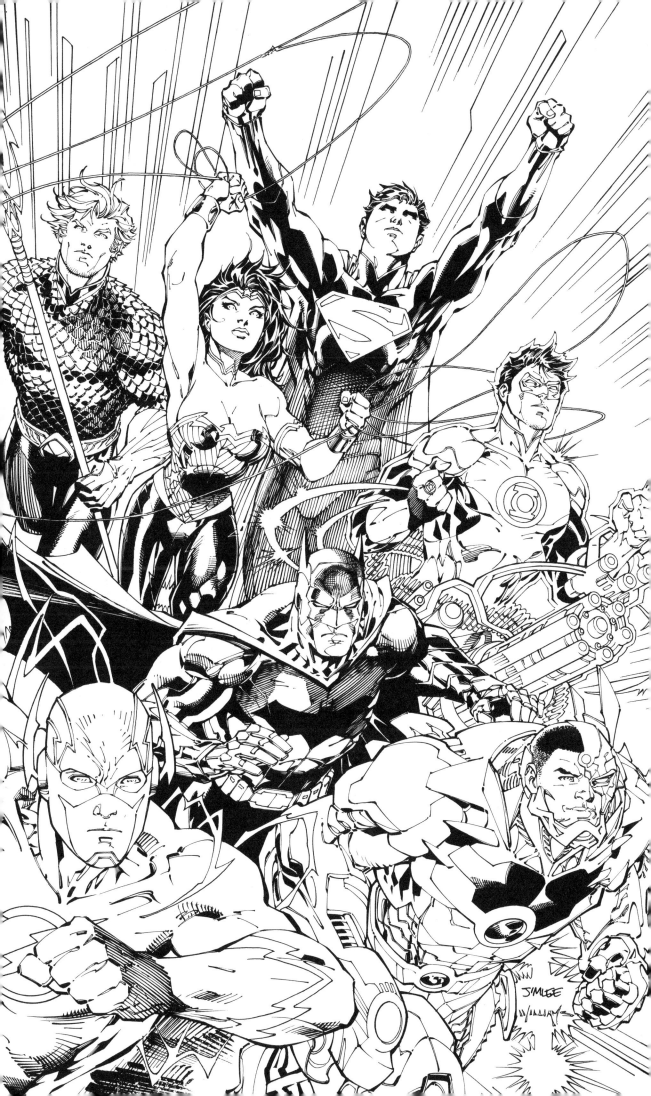

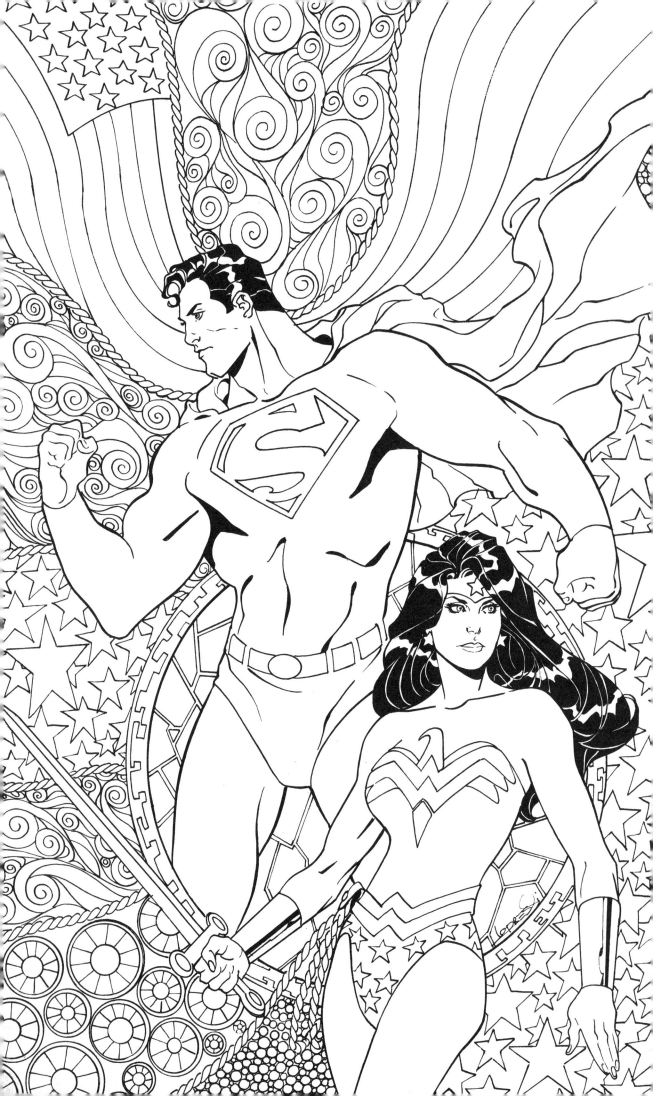

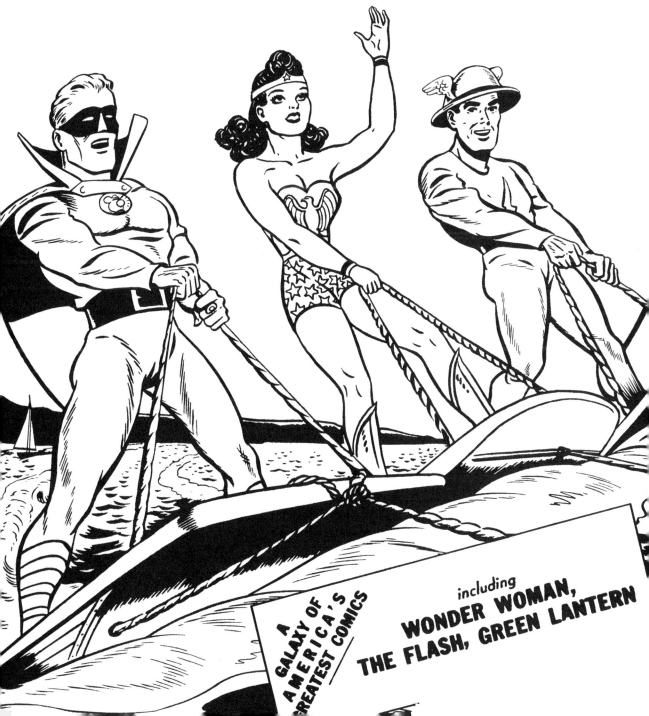

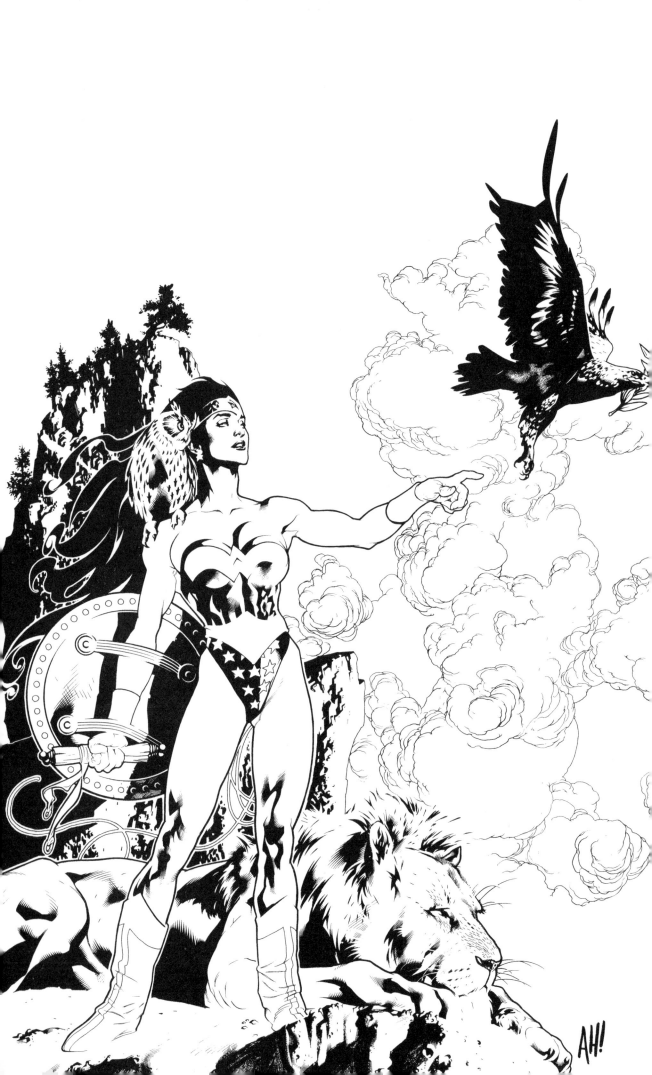

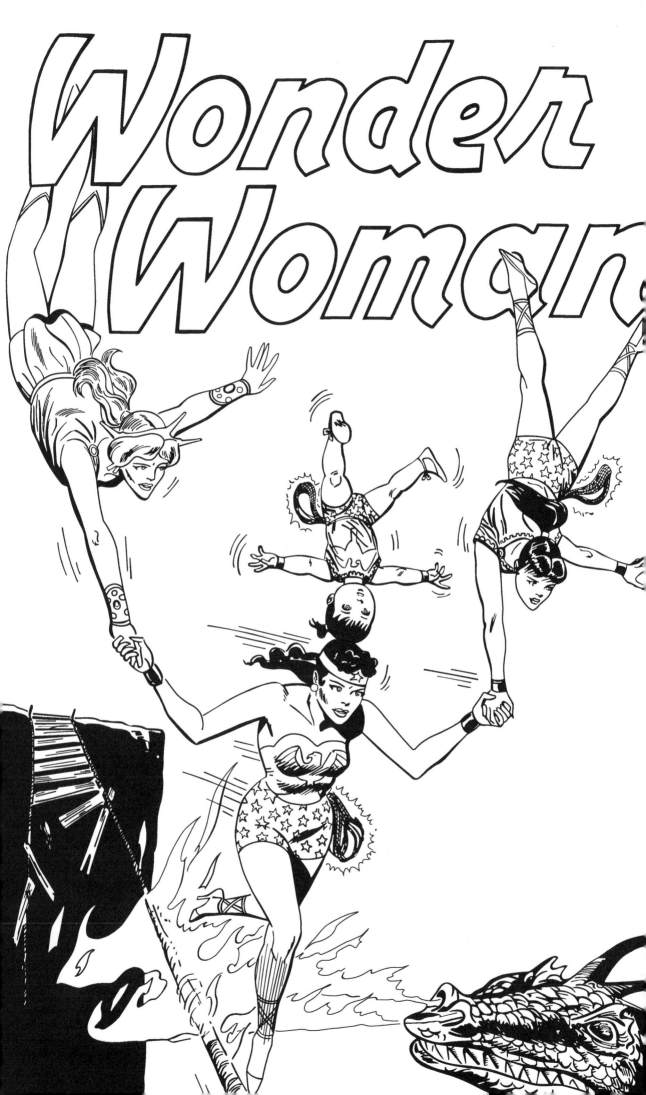

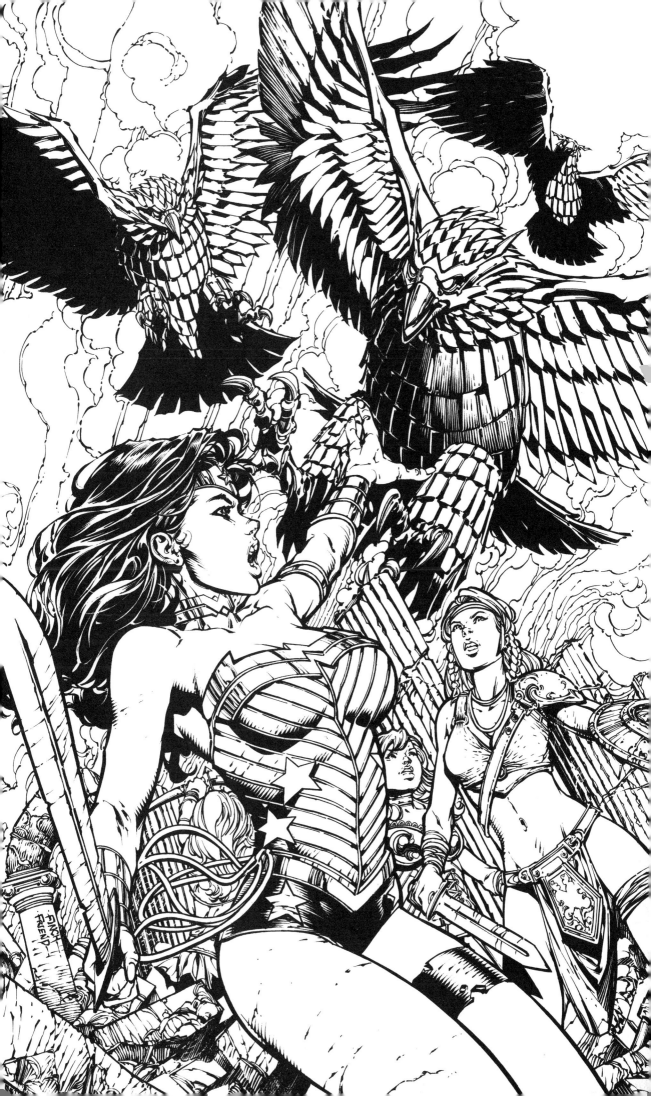

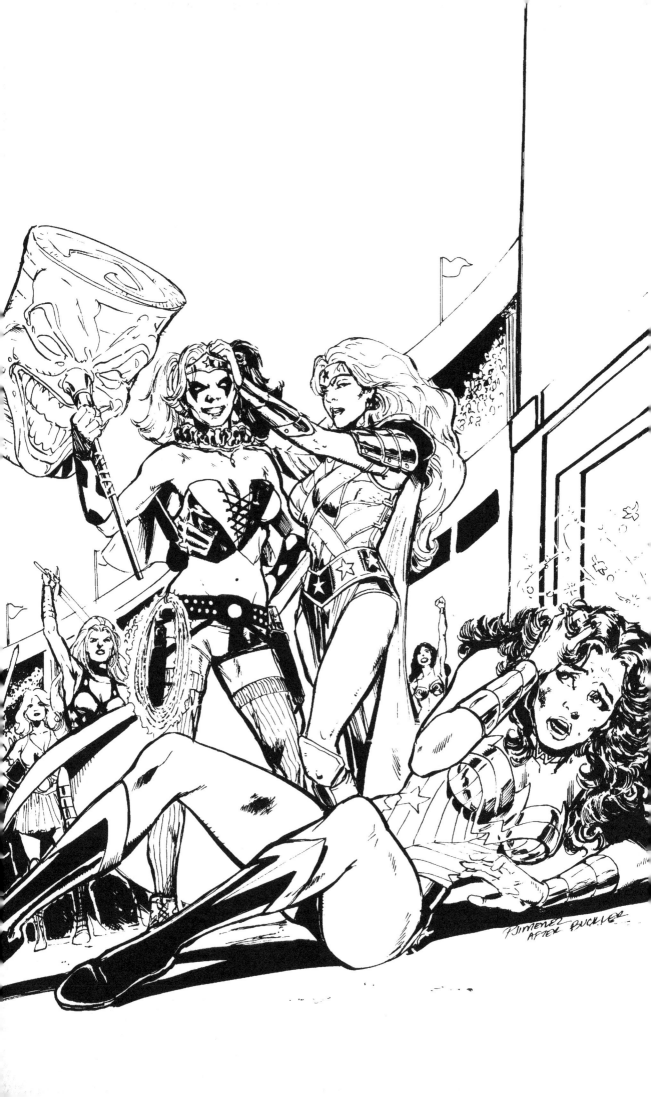

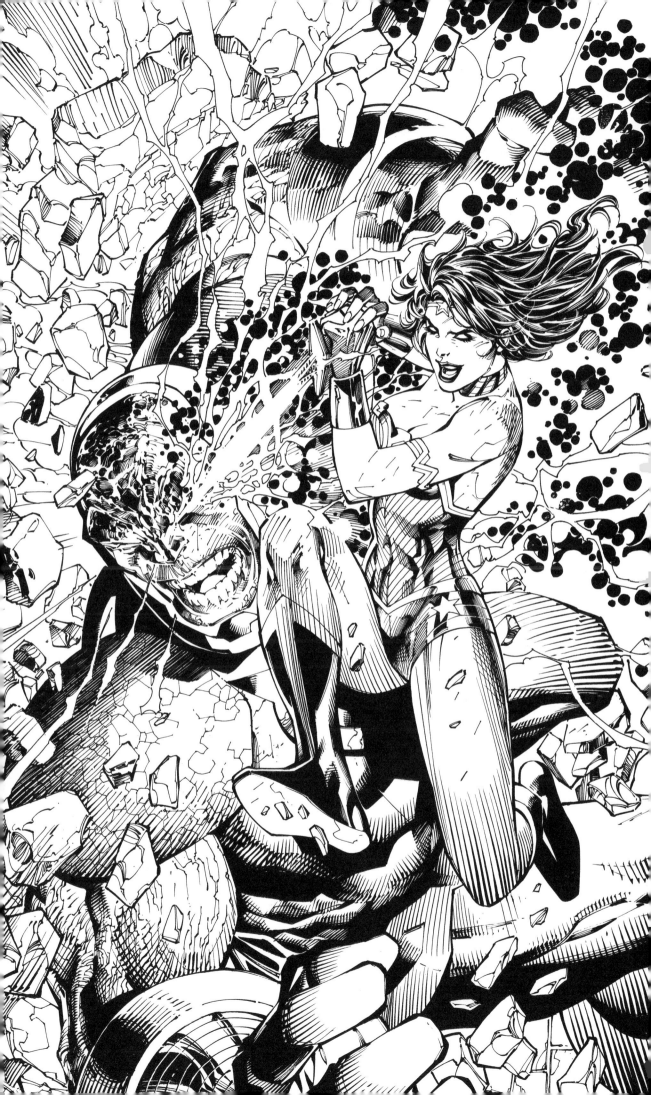

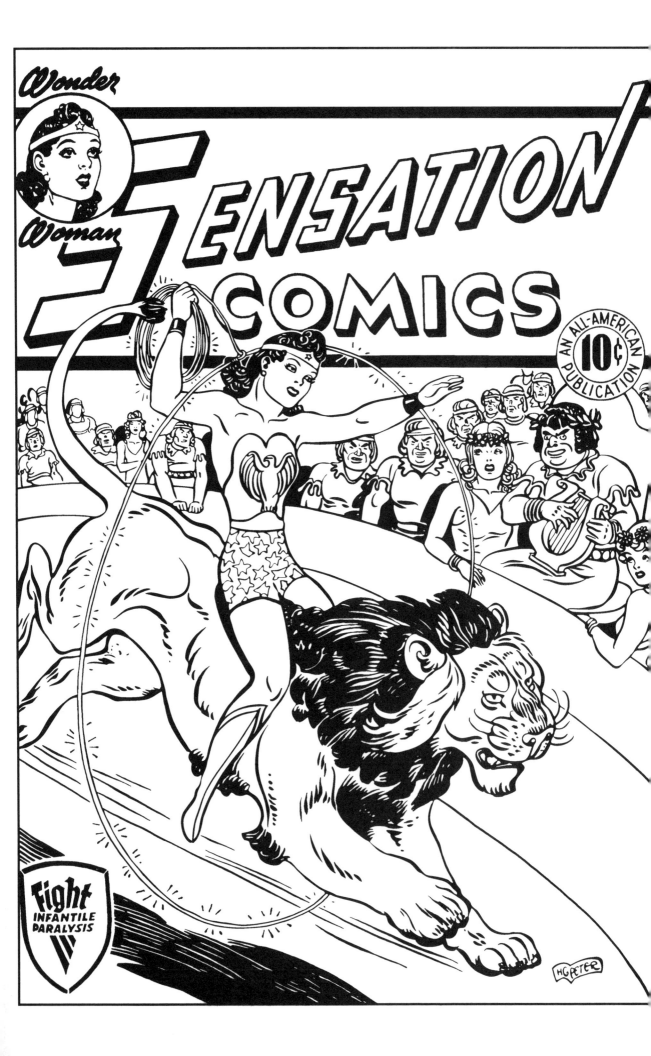

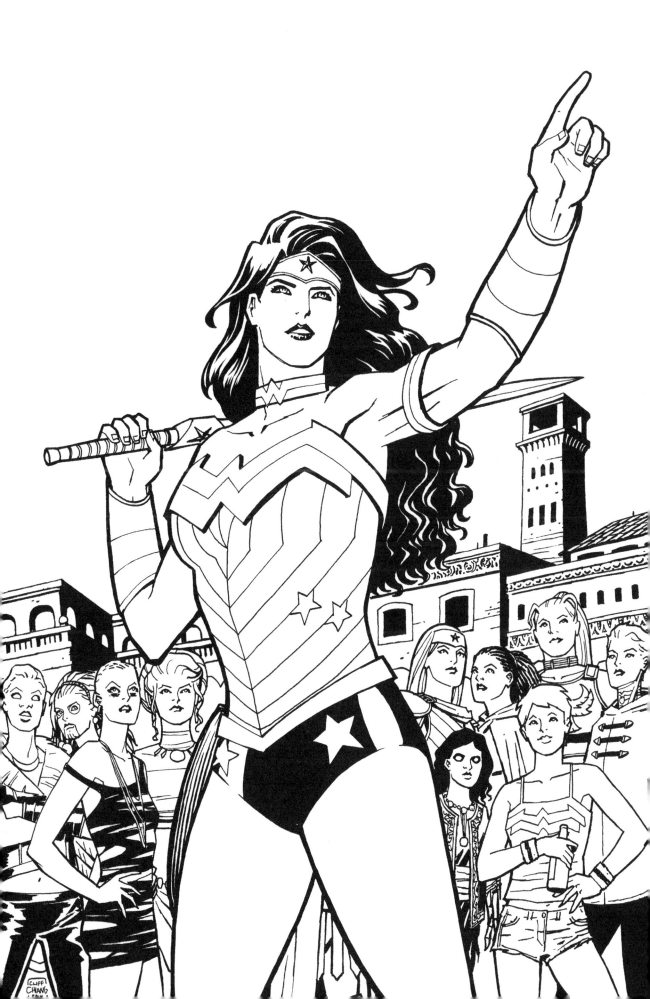

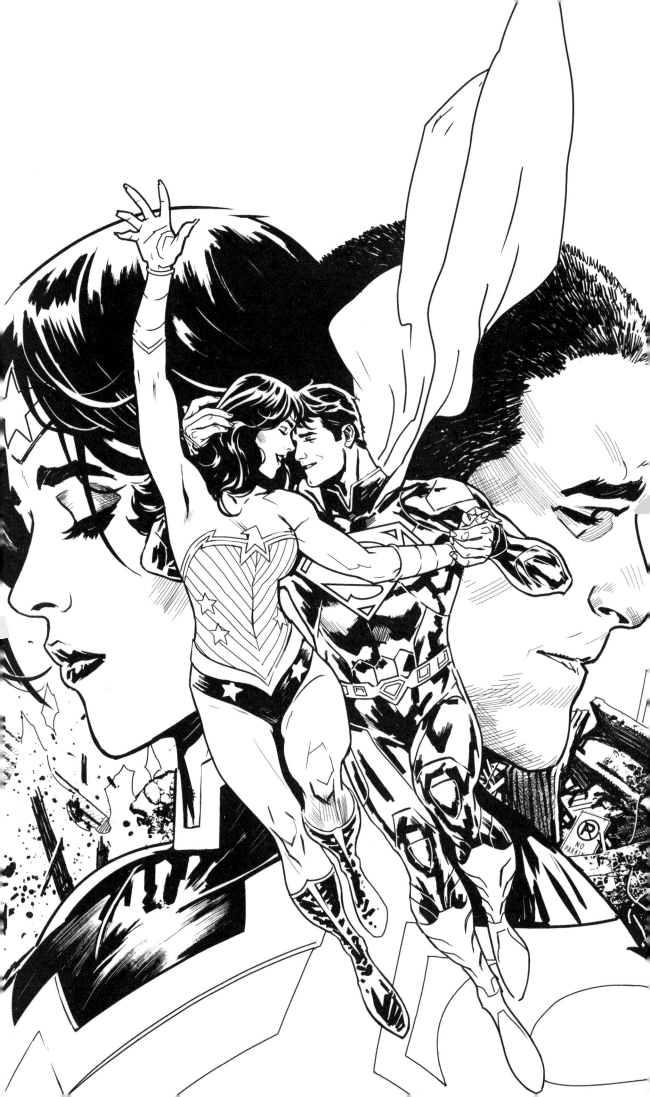

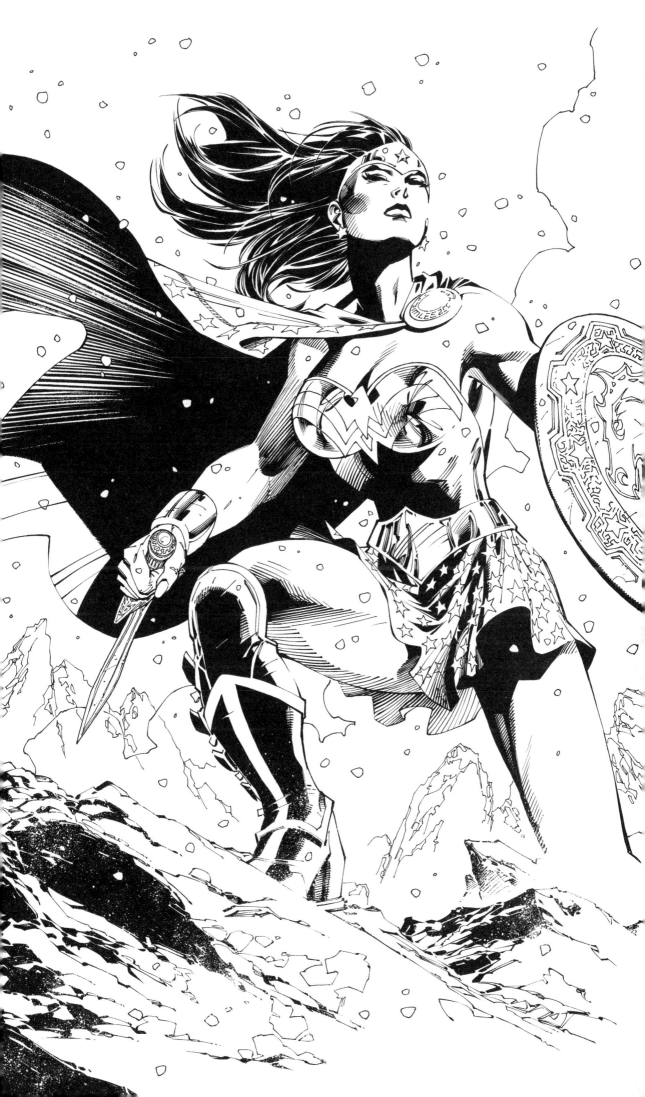

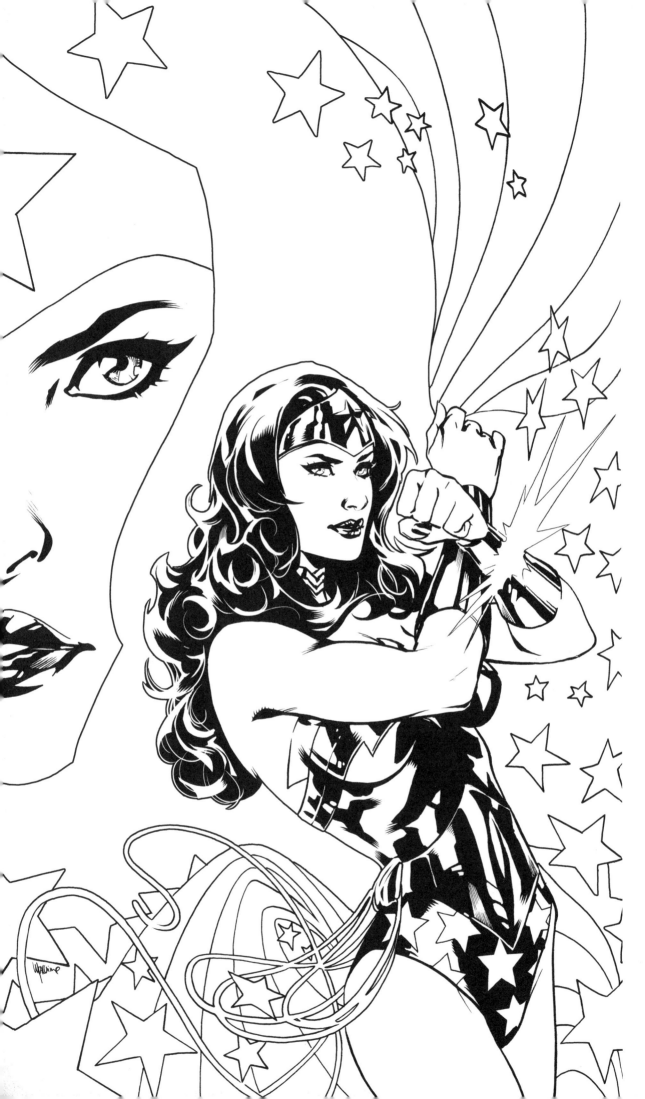

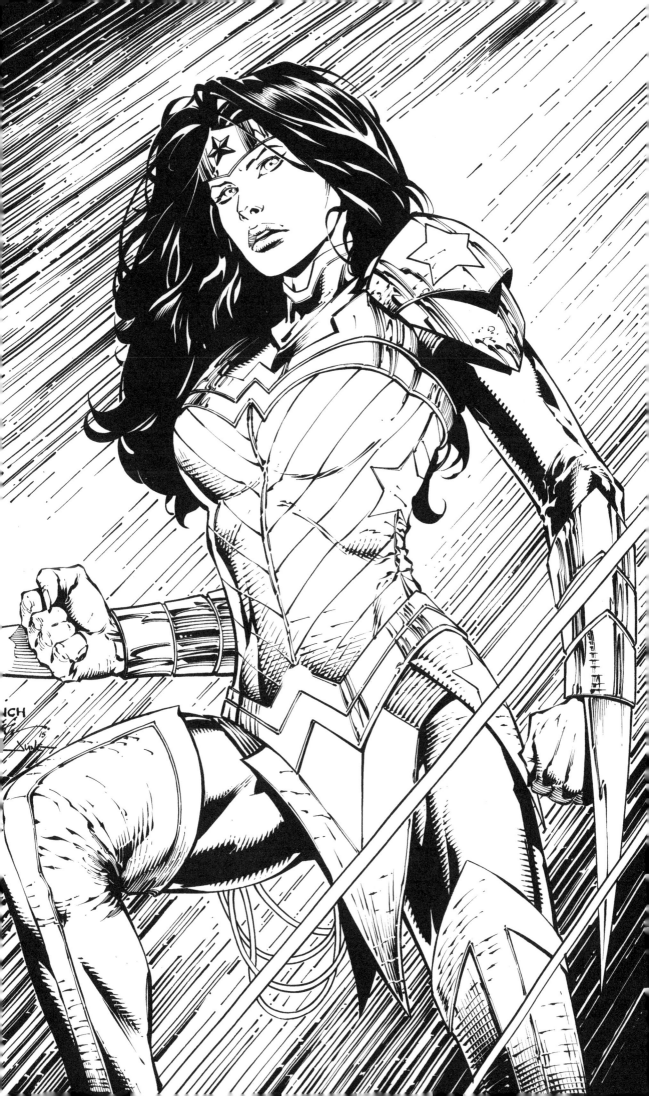

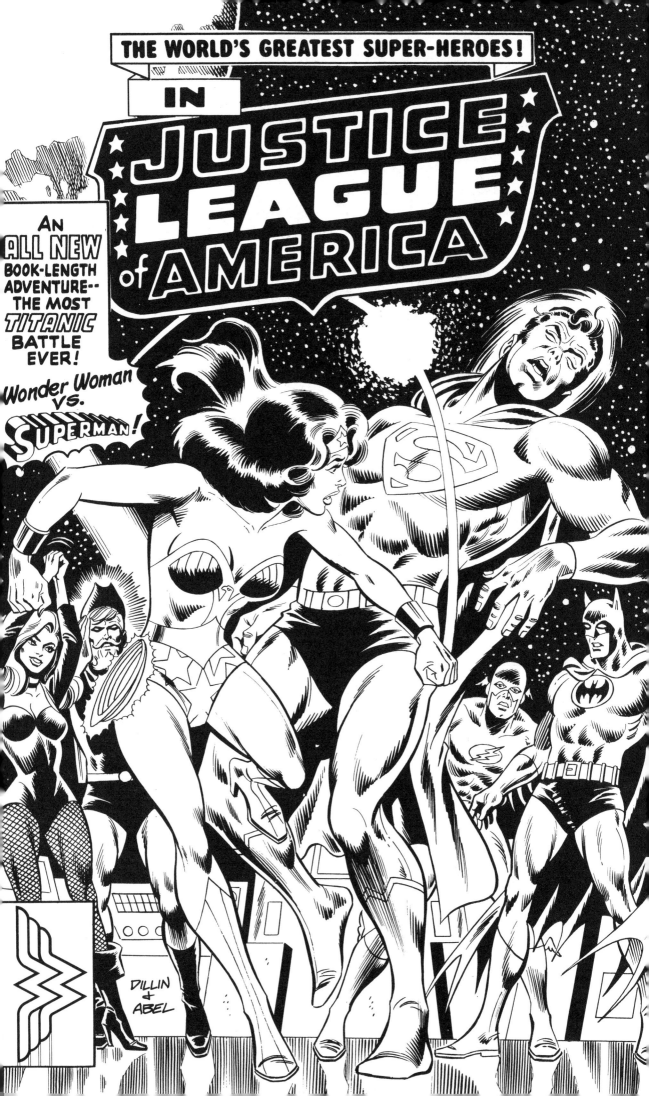

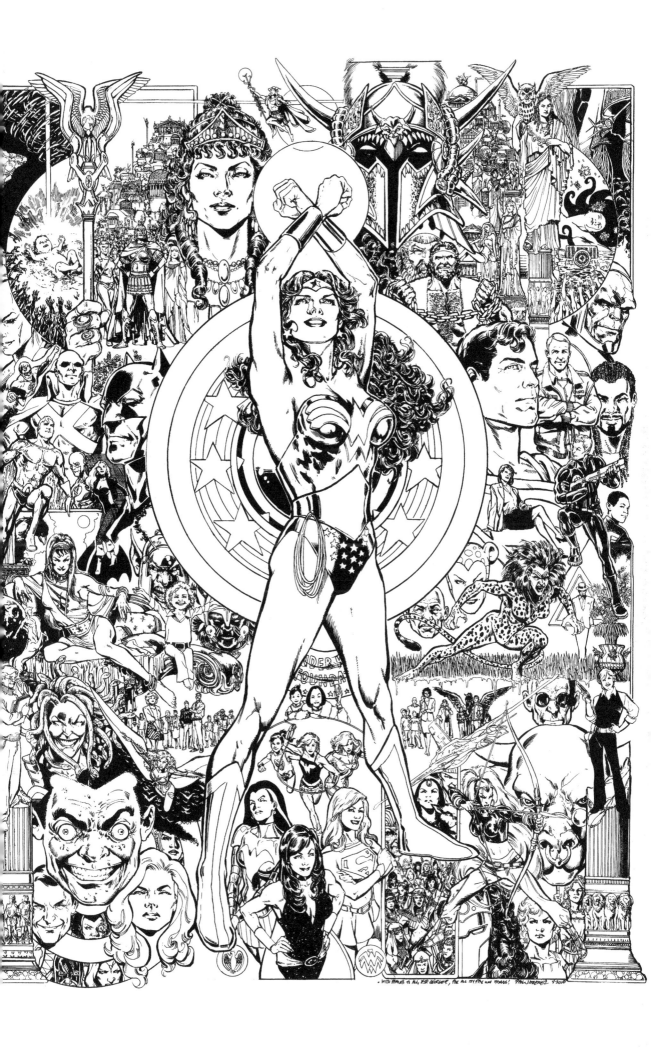

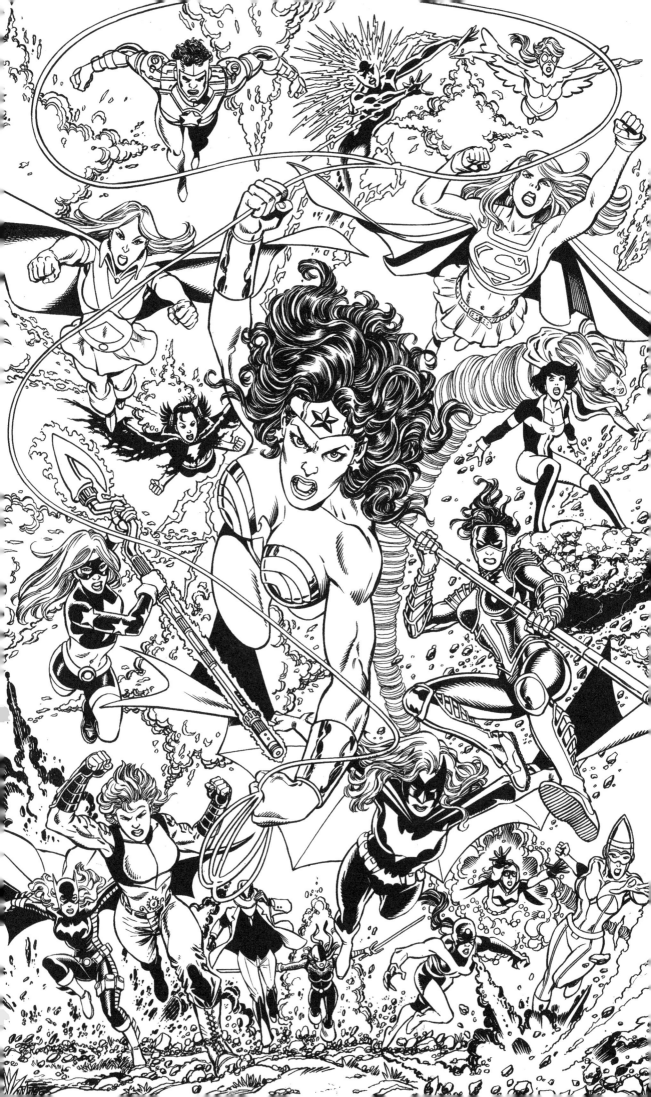

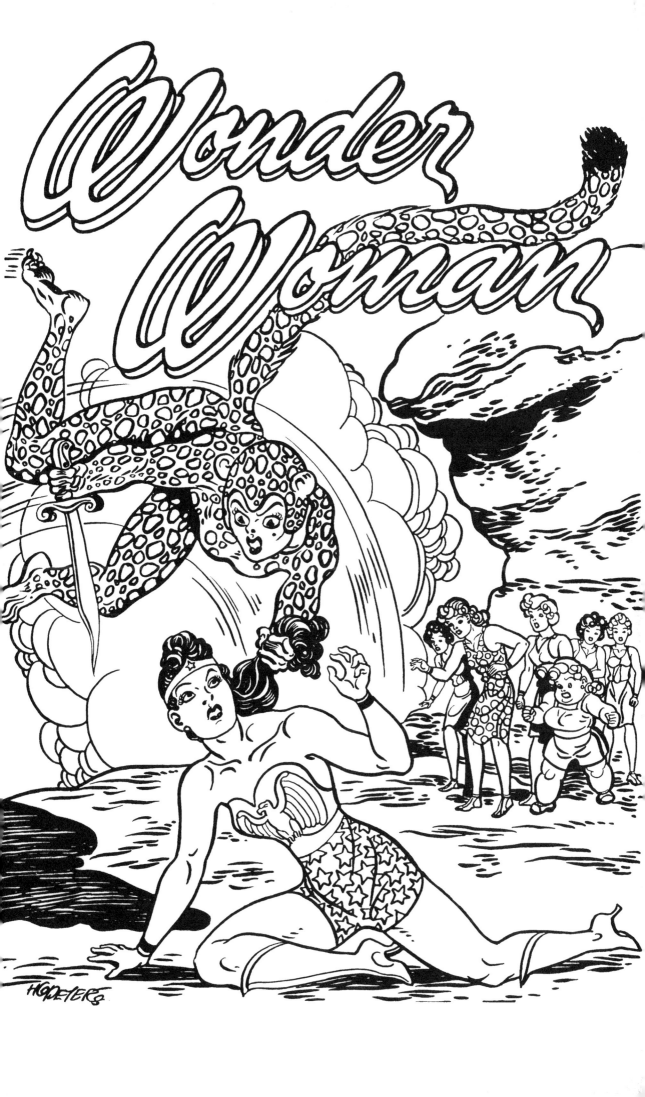

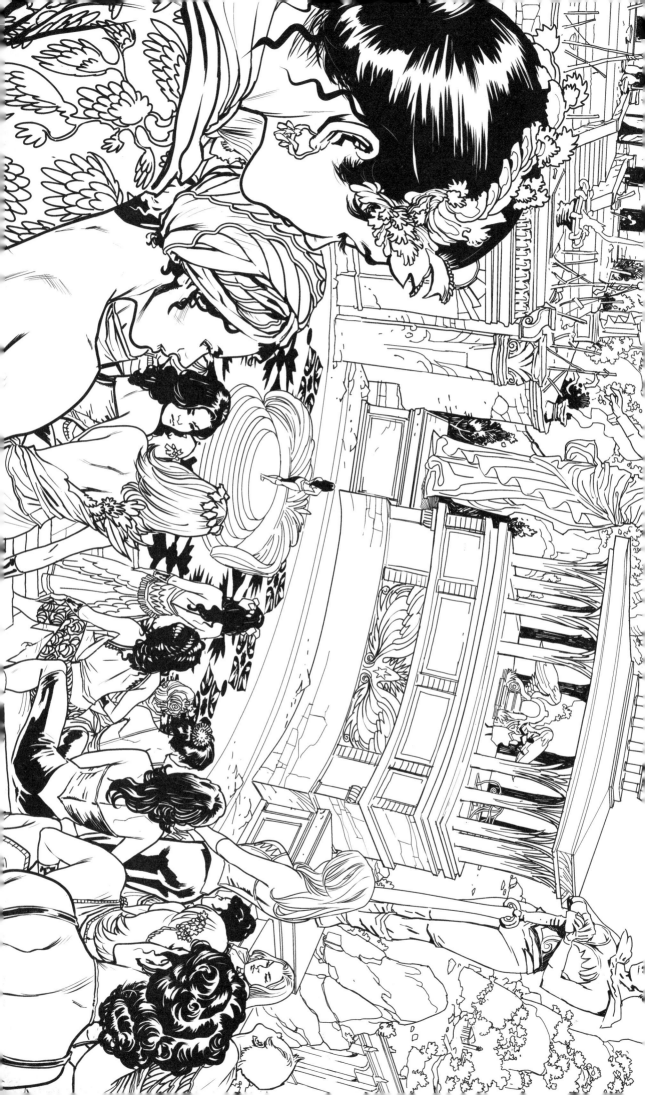

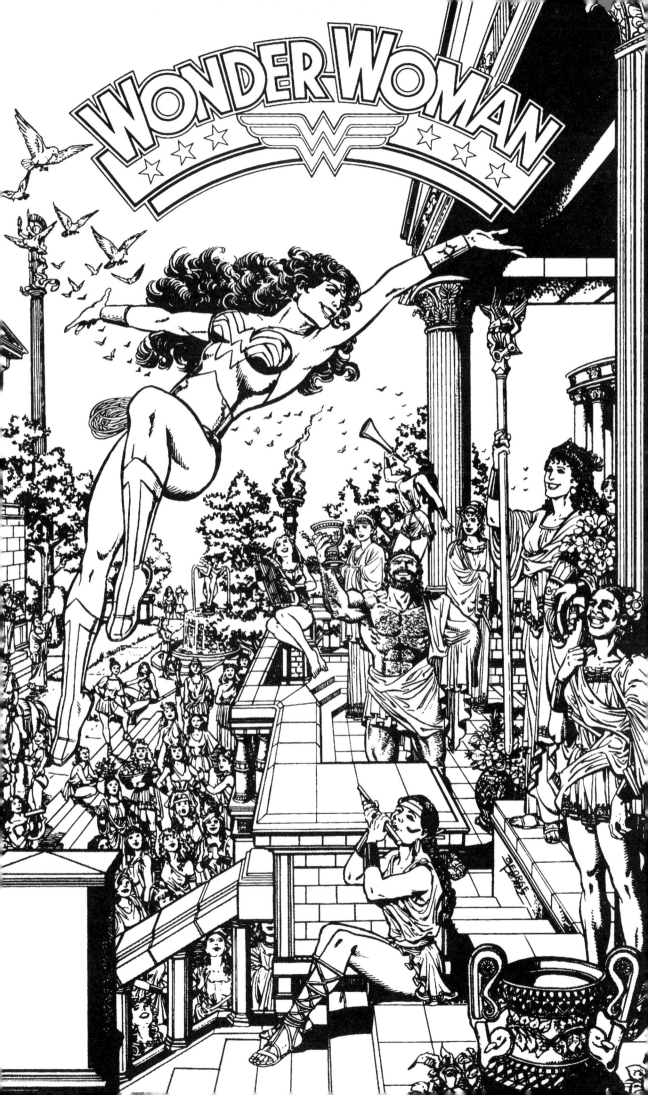

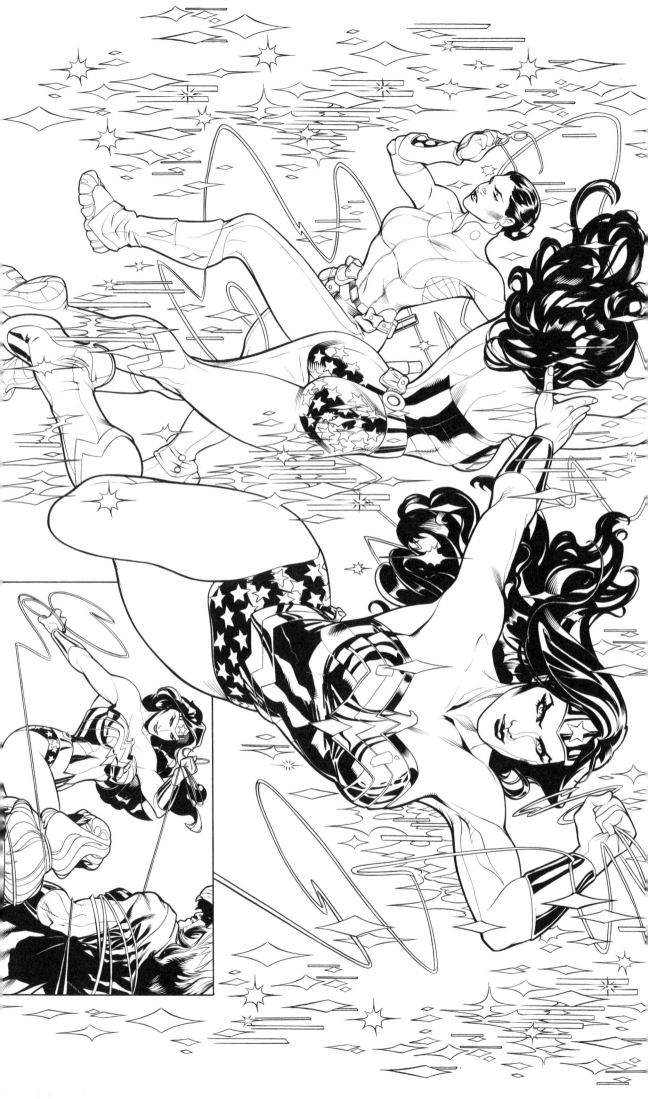

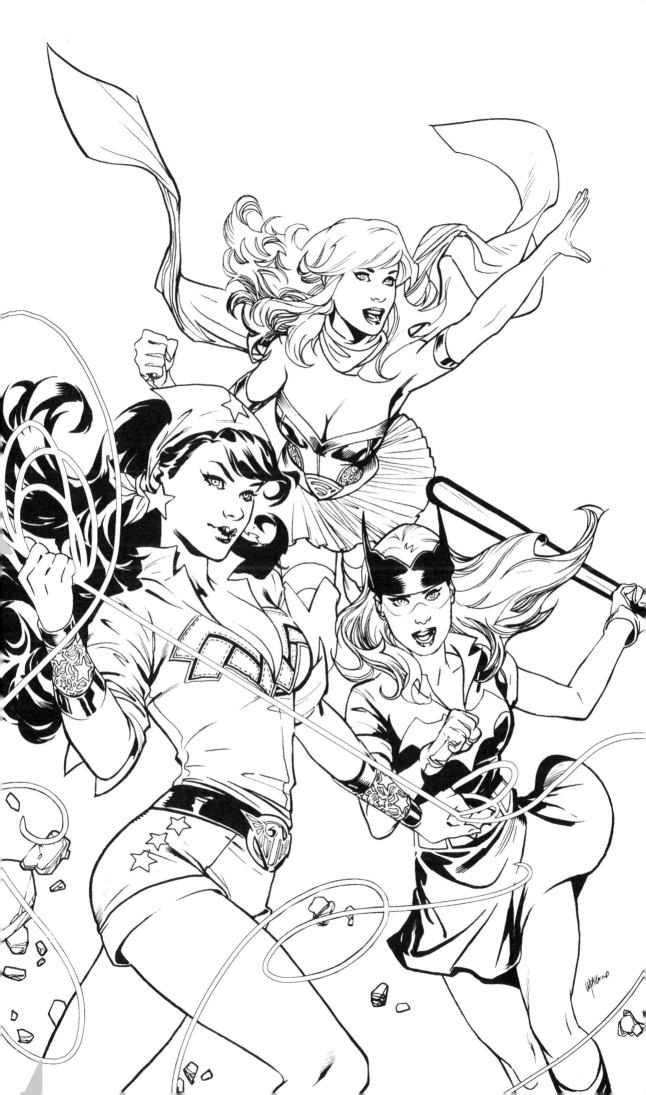

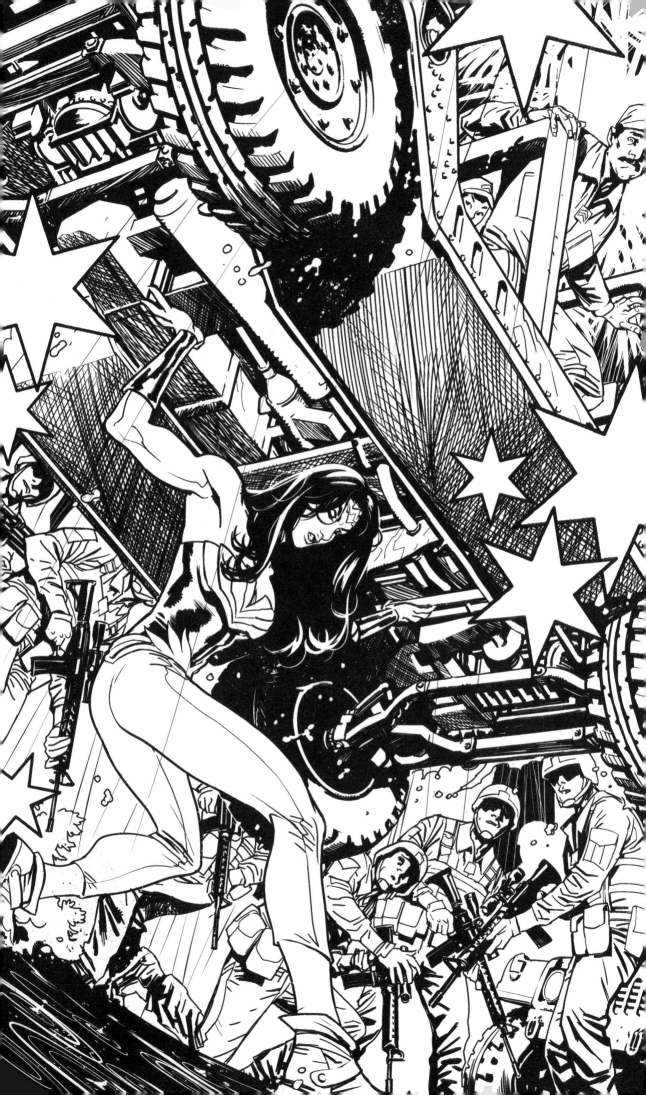

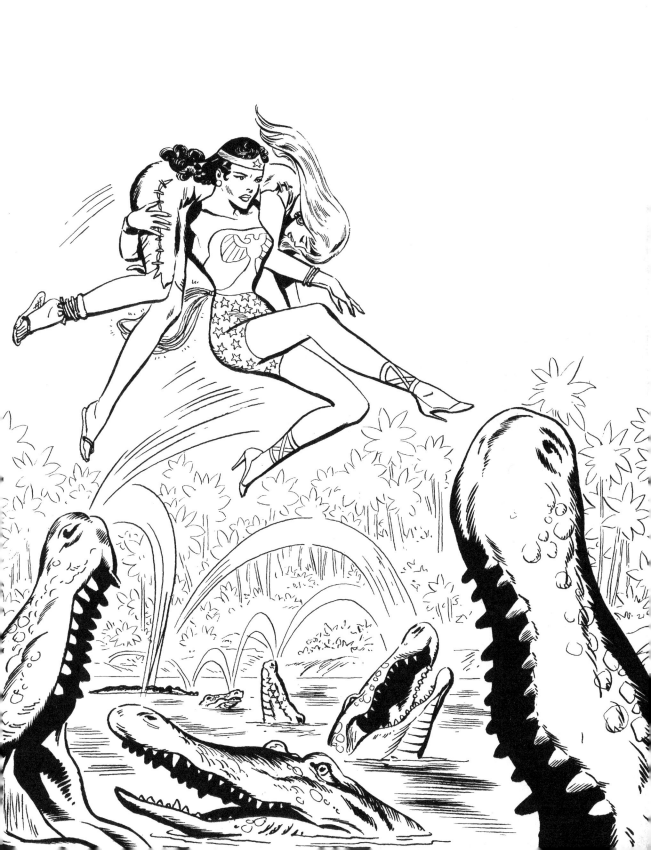

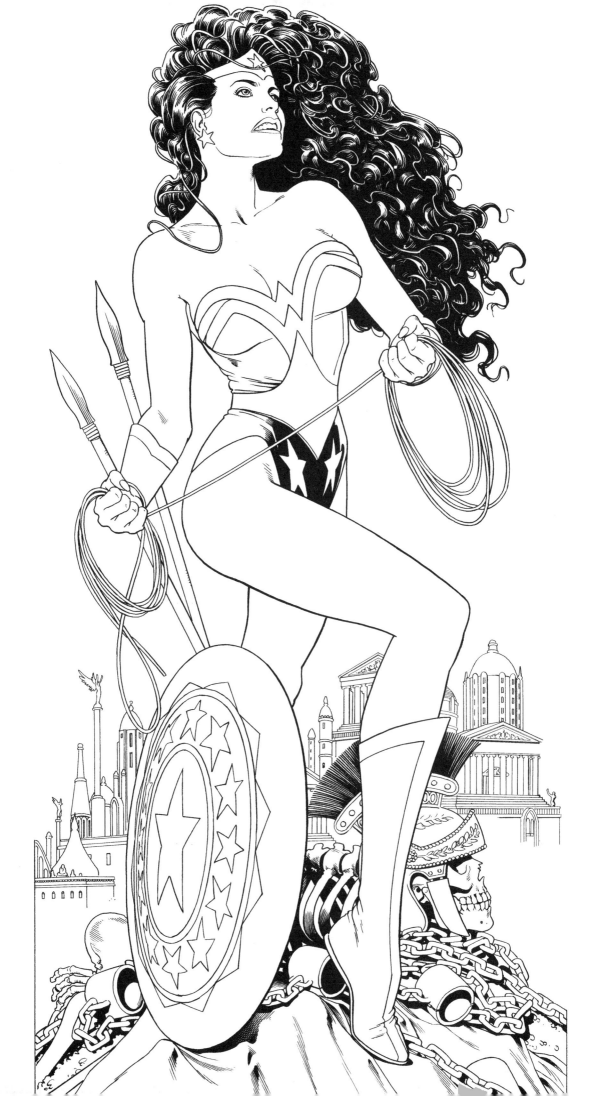

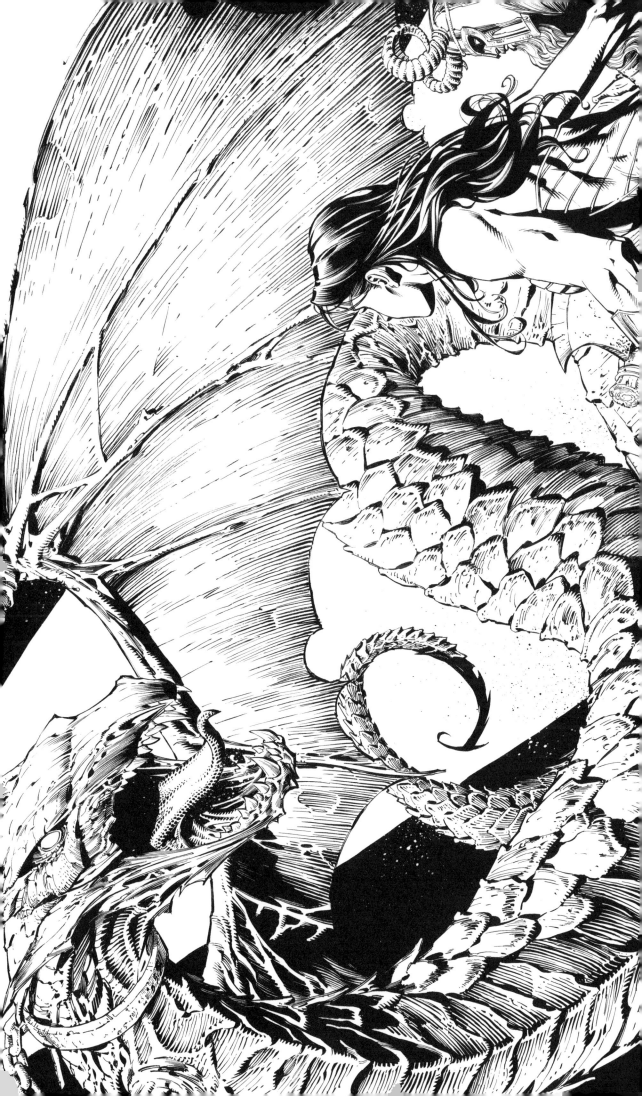

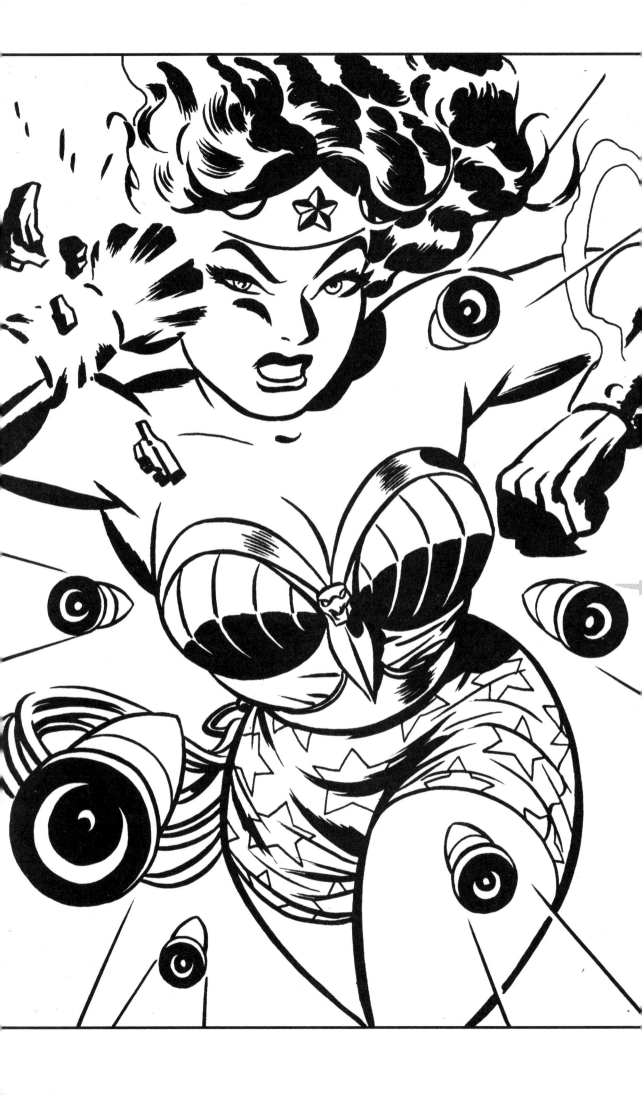

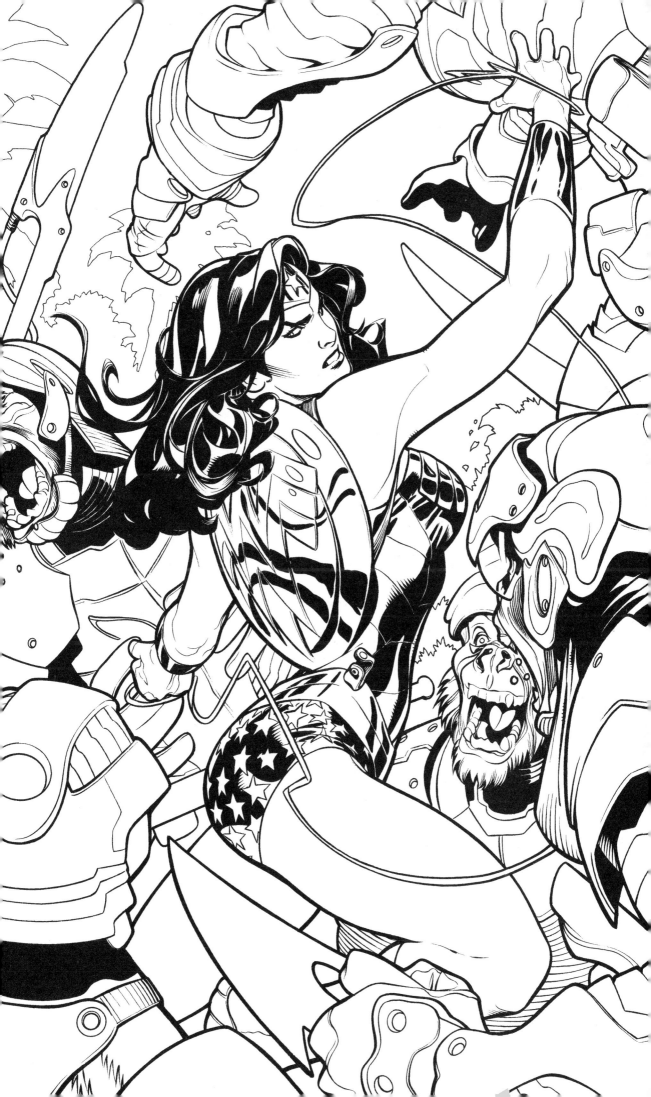

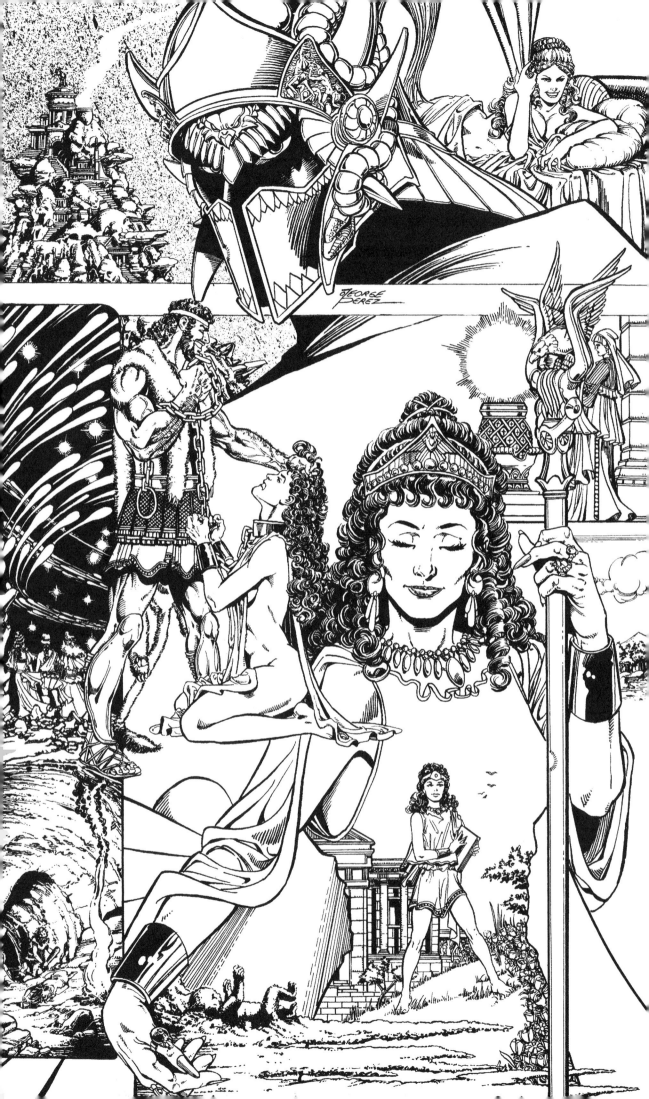

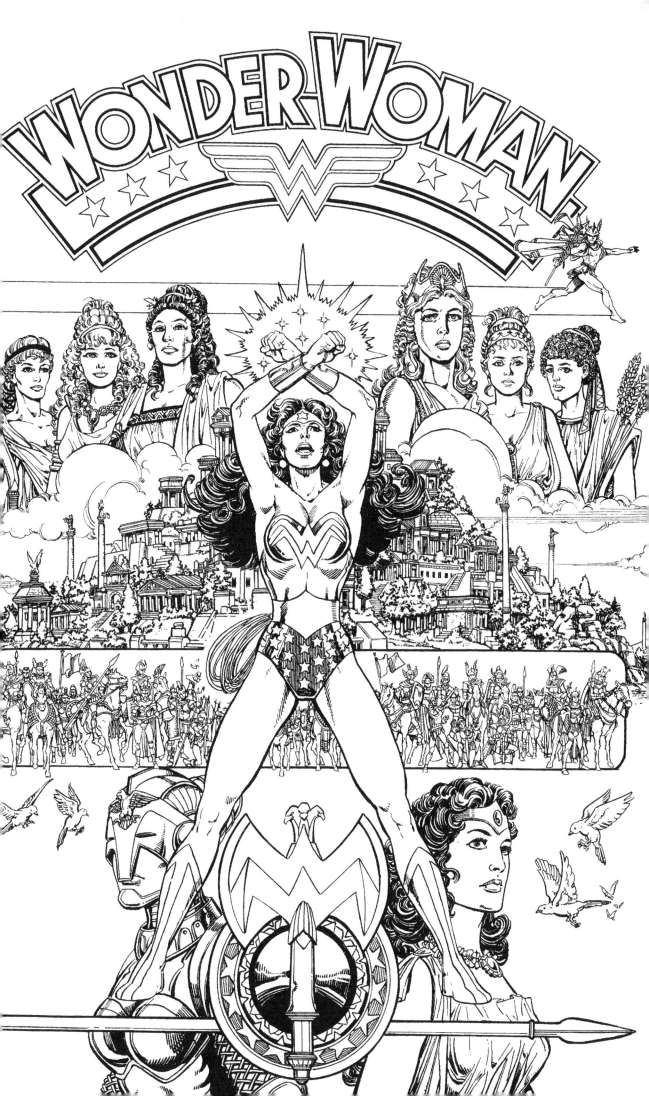

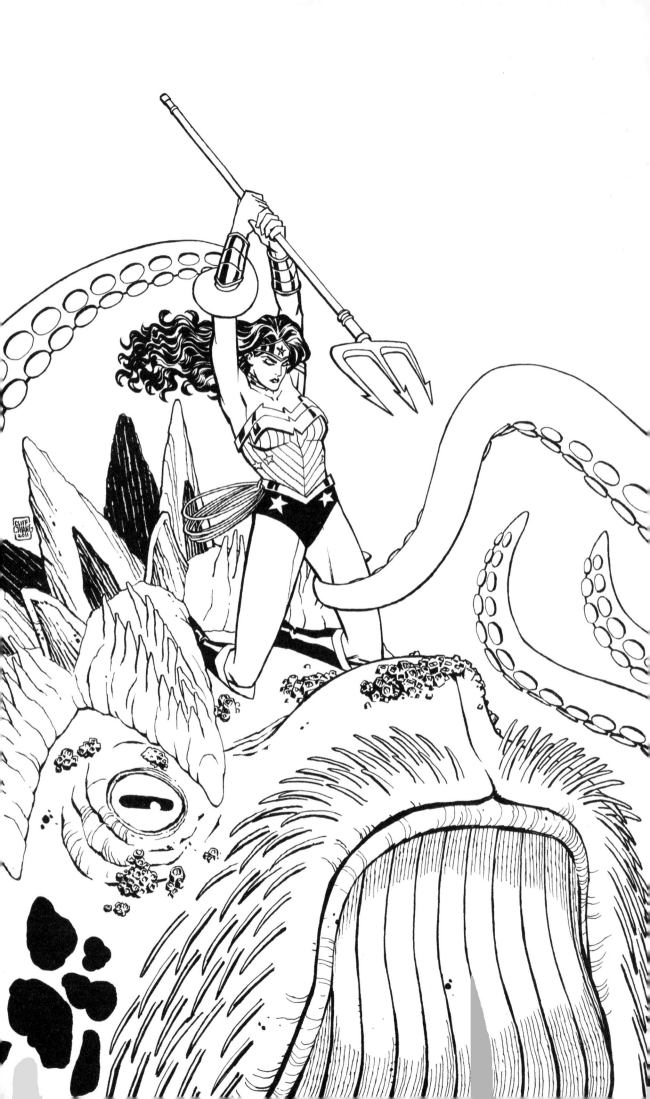

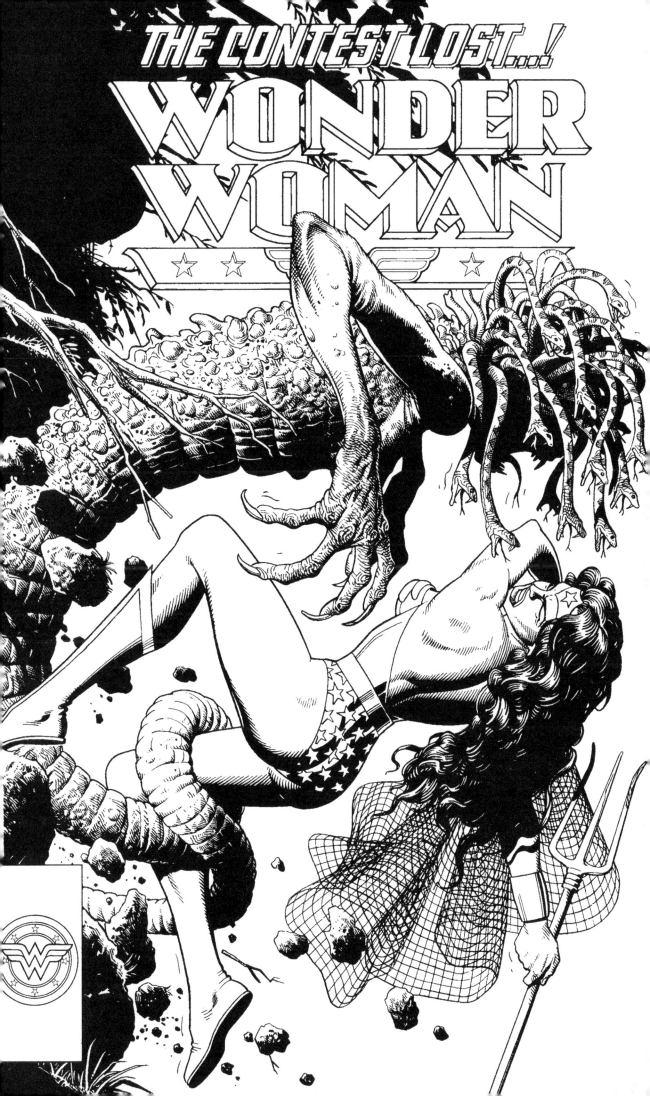

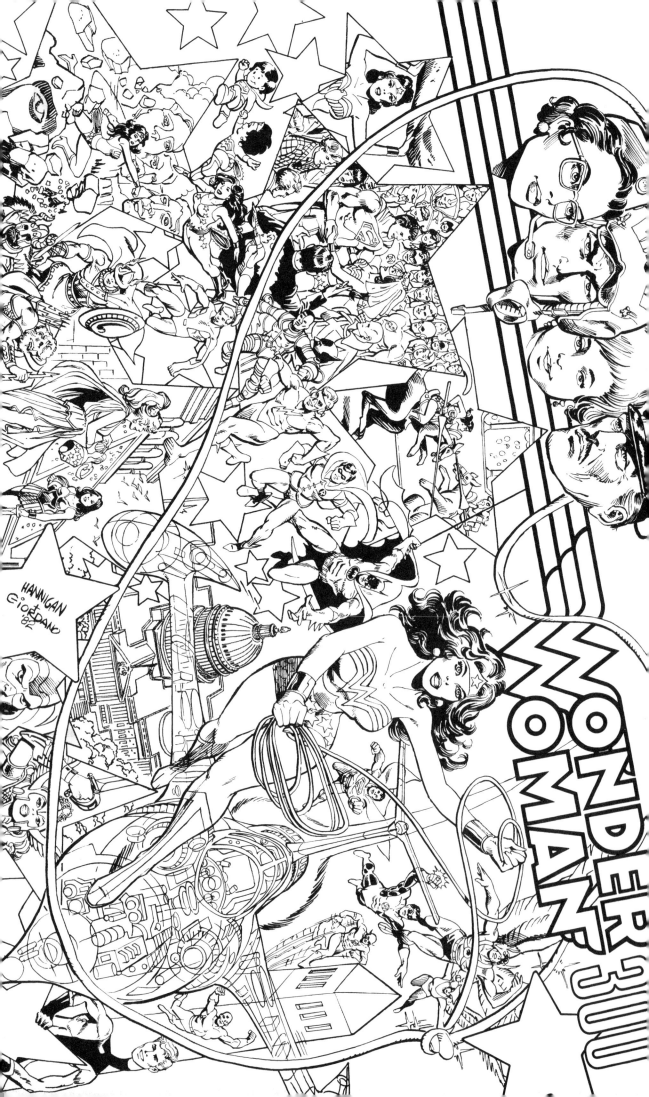

IN ORDER OF APPEARANCE

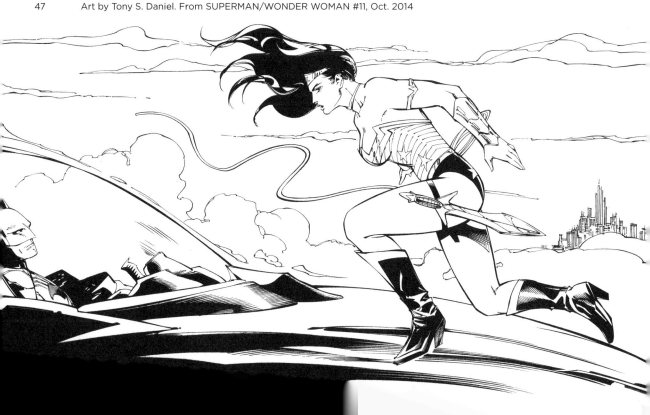

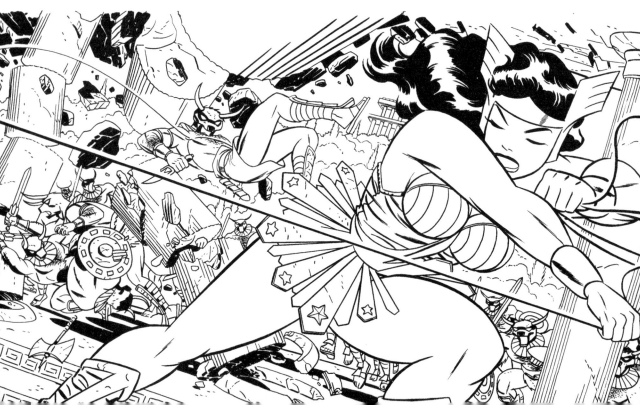